John Twachtman

John Twachtman

BY RICHARD J. BOYLE

WATSON-GUPTILL PUBLICATIONS, NEW YORK

For Patti, who likes all things French, this book has "a great deal of Paris in it";
for Cherie and Stewart; Barbara and Eric; Rick and Sandy; and lastly for Buffie and Tom.

Paperback Edition
First Printing, 1982

1 2 3 4 5 6 7 8 9/86 85 84 83 82

First published 1979 in the United States and Canada by Watson-Guptill Publications,
a division of Billboard Publications, Inc.,
1515 Broadway, New York, N.Y. 10036

Library of Congress Catalog Card Number: 79–12564
ISBN 0-8230-2569-1
ISBN 0-8230-2568-3 pbk.

Manufactured in Japan.

Front cover: *Windmills, Dordrecht*
Charles and Emma Frye Art Museum, Seattle, Washington

Edited by Dorothy Spencer
Designed by Robert Fillie
Composed in 12/14 Goudy Old Style

Preface and Acknowledgments

According to his biographers, John Henry Twachtman was a quiet, reserved, almost formal man—a very private person. In J. Alden Weir's melancholy portrait of him, he is shown in the dark coat, high stiff collar, and white piqué tie he was accustomed to wearing. Although he had many friends among his fellow artists, he did not have the easy ebullience of William Merritt Chase or the calculated showmanship of Whistler. Twachtman was basically a loner, and his solitary pursuits reflected this sense of privacy. He was fond of poetry, particularly that of Heinrich Heine, and music was a passion with him; his favorite composers were the Romantics—Brahms, Chopin, Schubert. His attitude toward nature was equally romantic and contemplative. He never allowed his bitterness at not being able to sell his work affect that attitude; in fact, his problems with public acceptance seemed only to intensify his interest in a natural world of his own choosing and his own making. Violet Oakley, a Philadelphia artist who studied under Twachtman at the Art Students League, remembered that "his appearance had great charm and interest . . . original force of character . . . strength and gentleness combined." Childe Hassam used almost the very same words, in 1903, to describe Twachtman's paintings.

Twachtman's mature work was not appreciated by the public of his day, and only recently has this quietly original artist begun to attract attention once again. Yet, not long after his death, his work began to appear in public collections across the country and was generally shown in museum exhibitions devoted to the subject of American landscape.

I am greatly indebted to those museums and individuals who have generously and graciously made their paintings available for reproduction in this book and to the many people who have made the book possible and real. My thanks in particular to Don Holden of Watson-Guptill, who suggested the idea in the first place and whose enthusiasm kept it alive and well; to Ira Spanierman, who generously provided me with copies of the Twachtman-Weir correspondence; and to Donelson Hoopes, whose insights are always stimulating and valuable. Special thanks to my editor, Marsha Melnick, who was terrific to work with; my copyeditor, John Kremitske; and a very special thanks to my assistant at the Pennsylvania Academy, Marcela DeKeyser, who really went out of her mind typing the manuscript against a very tight deadline.

Lastly, it should be pointed out that anybody interested in this marvelous artist owes a great debt to Professor John Douglas Hale, whose initial and invaluable research on Twachtman prepared the way and made it easier for the rest of us.

Richard J. Boyle
Philadelphia
January 1979

Color Plates

Chronology

1853. Born August 4, in Cincinnati, Ohio.

1868. Enrolls in the evening school, Ohio Mechanics Institute, Cincinnati.

1871. Enrolls at McMicken School of Design, part-time day school (McMicken School later became the Art Academy of Cincinnati).

1874. Meets Frank Duveneck, just returned from study in Munich, who teaches at McMicken School. Enrolls full-time and also studies with Duveneck privately.

1875. Joins Duveneck and Henry Farny on trip to Europe to study. Enrolls at Royal Academy of Fine Arts, Munich.

1877. First trip to Venice to paint with Duveneck and William Merritt Chase.

1878. Returns to Cincinnati (father's death). Exhibits with newly formed Society of American Artists, New York.

1879. Paints in New York and on East Coast. Elected to Membership in Society of American Artists. Exhibits for first time at National Academy of Design. Meets J. Alden Weir in New York. Joins faculty of Women's Art Association of Cincinnati.

1880. Paints on East Coast and in New England during summer. Joins staff of Duveneck's school in Florence in fall.

1881. Back in Cincinnati, marries Martha Scudder. Travels to Europe on wedding trip. Paints in Holland and Belgium with J. Alden Weir and John Weir. Meets Anton Mauve and Jules Bastien-Lepage.

1882. Back in Cincinnati for birth of his son, named J. Alden in honor of Weir. Paints in Cincinnati area.

1883–1885. Travels to Paris. Studies at Académie Julien and paints in French countryside, at Honfleur and Arques-la-Bataille, near Dieppe. Meets Theodore Robinson, Childe Hassam, and Willard Metcalf in Paris. Wife and family (daughter Marjorie born in Paris) return home in spring of 1885. Twachtman joins Duveneck and Blum in Venice that summer and fall.

1887. Crate of his paintings lost at sea in sinking of *H.M.S. Oregon.* Paintings later salvaged and sold at auction. Ranges up and down East Coast and Canada looking for work. Reunited with family, lives in Greenwich and Cos Cob, Connecticut. Paints cyclorama in Chicago with Arthur B. Davies.

1888. Exhibits with "Painters in Pastel." Wins Webb Prize for landscape, Society of American Artists.

1889. Exhibits in two-man show with J. Alden Weir (financial success). Teaches summer class in Newport, Rhode Island. Begins teaching at Art Students League of New York. Purchases farm on Round Hill Road, Connecticut, where his best-known pictures were painted. Does illustrating for *Scribner's Magazine* (until 1893).

1891. One-man show at Wunderlich Gallery, New York.

1893. Exhibits with J. Alden Weir, Claude Monet, and Paul Besnard, American Art Galleries, New York. Receives silver medal at Chicago World's Columbian Exposition.

1894–1895. Joins faculty of Cooper Union, New York. Visits Buffalo to paint Niagara Falls on commission. Wins Temple Gold Medal in 64th Annual Exhibition, Pennsylvania Academy of the Fine Arts, December 1894, Receives medal in 1895. Paints in Yellowstone Park on commission.

1897. Instrumental in formation of The Ten American Painters, who withdraw from Society of American Artists to hold exhibitions of their own. "The Ten" include Childe Hassam, J. Alden Weir, Thomas Dewing, Joseph De Camp, Edmund Tarbell, Edward Simons, Robert Reid, Frank Benson, and Willard Metcalf. William Merritt Chase joins after Twachtman's death in 1902.

1898. First exhibition of The Ten at Durand Ruel Galleries, New York, in March.

1900. Exhibits with his son J. Alden in two-man show at Cincinnati Art Museum. Paints in Gloucester, Massachusetts.

1901. Has one-man exhibition at Durand-Ruel Galleries, New York, and Cincinnati Art Museum, Ohio.

1902. Dies suddenly in Gloucester on August 8.

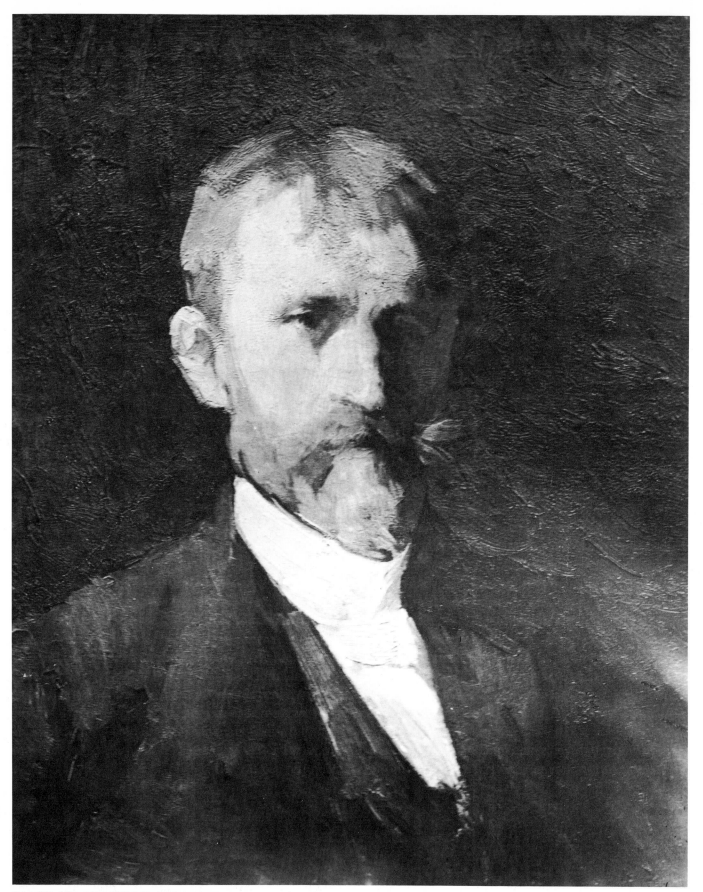

PORTRAIT OF JOHN H. TWACHTMAN, 1894 by Julian Alden Weir, oil on canvas, 21½″ x 17¼″ (54.6 cm x 43.8 cm)
Cincinnati Art Museum (Gift of the Artist)

John Twachtman

"It sounds like a paradox, but it is a very simple truth, that when today we look for 'American art' we find it mainly in Paris. When we find it out of Paris, we at least find a great deal of Paris in it."

<div align="right">Henry James, 1893</div>

John H. Twachtman was an American Impressionist painter. He was born in 1853, during the heyday of the Hudson River School, and his development as an artist reflects some of the changes, the style-conscious movements, which swept through the arts in that era and which gathered momentum as the century progressed. In his early years, like many of his colleagues, he was absorbed in realism and pleinairism; his painting, in that constant search for his own point of view, partook of tonalism and aspects of Romanticism until finally, at the time of his death in 1902, all these approaches had been assimilated into a generalized form of Impressionism.

As everyone knows, Impressionism originated in France, and, after several stormy years, became international in scope. Conceived in the 1860s, and radical at the time, this style achieved the status of a juvenile delinquent in the eyes of the public for a considerable period after its birth and baptism at the first exhibition of that now-famous group—Monet, Pissarro, Sisley, Degas, and their friends—in 1874. But by the mid-1880s it had become more respectable, even acceptable; and by the 1890s, when it took hold in the United States, it was downright fashionable in Paris. It was cheerful, frank, and direct painting that depicted the everyday activities of the French middle class. Technically, Impressionism revolutionized the art of painting by its concern with that very art of painting.

Like the Barbizon painters before them, or in fact like the American Hudson River School artists, the Impressionists rejected the artificial subject picture in favor of painting out-of-doors. But the Impressionists went further than either of these prior movements. They broke with the old conception of a picture as a classically ordered unit in time and space—the idea of "a window on nature," so to speak—and substituted instead the casual passage of time, "a fleeting moment," a fragment from continuous space and time signifying movement and change. Hence the ever-changing elements, the representation of overall light and atmosphere, became their common concern. Claude Monet was their spokesman when he said that "nature does not stand still."

The representation of light and atmosphere was achieved with a *seemingly* casual, spontaneous execution through the use of color that was bright, variegated, to a large extent newly discovered and used in a new way. Because of Impressionist painting, representing light and the subtle variations of atmosphere through color eventually became common practice among most painters.

After the Impressionist style was adopted by American artists, and as its influence gained momentum and general acceptance in the United States, there were few who were immune to it, including those who expressed strong opposition. George Inness, for one, was incensed when the art critic of a Florida newspaper classified him as an Impressionist, and Kenyon Cox railed against its "pernicious" influence. But there were many others who adapted its techniques to American attitudes, traditions, and ways of thought. The best of these Americans created intensely personal, even original styles. One of the best, and certainly one of the most sensitive and singular of all the American Impressionists, was John Henry Twachtman.

John Twachtman was born on August 4, 1853, in Cincinnati, Ohio. His parents, Frederick Christian

Twachtman and Sophia Droege, had come from Hannover, Germany, most probably in the late 1840s, when there was a tremendous influx of German immigrants to the United States as a result of the failure of the liberal revolution of 1848. The immigration of German people to Cincinnati was quite large; in fact, by the time of Twachtman's birth they constituted one-fourth of the city's population.

Frederick Twachtman and Sophia Droege met in Cincinnati, where they lived in an area known familiarly as the "Over-the-Rhine" district. Not only did most of the city's German populace live there, but it was cut off from the remainder of Cincinnati, in a manner of speaking, by the Miami Canal, which connected with the traffic on the Ohio River. The center of this large German-speaking district was Vine Street, in its day as famous as Broadway, along which were situated numerous celebrated saloons and beer gardens. The Twachtman home was located four blocks from the canal, in the heart of the "Old World" section of Cincinnati.

The families of both Twachtman's parents seem to have been of some importance in Hannover; but in Cincinnati, Twachtman's father was evidently a man-of-all-work, who was at various times a policeman, storekeeper, carpenter, and cabinetmaker. He was best known, however, as a decorator of window shades, a popular form of decorating in the mid-nineteenth century: "Window shades with milkmaids and ruined castles stencilled on them," as Mark Twain mentions in *Life on the Mississippi*. Frederick Twachtman worked for Breneman Brothers Window Shade Factory, where John Twachtman himself started working when he was fourteen. Apart from this fact and that of his enrollment in the Ohio Mechanics Institute, and subsequently in the McMicken School of Design, not too much is known about Twachtman's boyhood. Except for the terse comment that he had "some pretty bad years," he was reticent about it with his biographers. However, it can be inferred from them that probably a good part of his unhappiness lay in the age-old question of his desire to be an artist versus his parents' objections to that desire.

When Twachtman started working at the Brene-

man Brothers factory in 1867, the post–Civil War Cincinnati that lay outside the flourishing German district was relatively young and not long out of the frontier stage. Charles Dickens noted this aspect of the city when he visited there in 1842, writing about it in his book *American Notes*. "The inhabitants of Cincinnati," he said, "are proud of their city as one of the most interesting in America: for beautiful and thriving as it is now, . . . but two and fifty years have passed since the ground on which it stands was a wild wood." Situated in the southwestern part of the state on a bend of the Ohio River, directly across from Covington, Kentucky, Cincinnati was already a commercially active city of breweries and banking, increasing industrialization, particularly the machine-tool business, manufacture of boots and shoes, whiskey distilling, and winemaking, from the conveniently cheap Catawba grape that grew plentifully on the surrounding hills. It was also a city of meatpacking, especially pork. Railroading was a coming industry, soon to replace the riverboats, those "floating palaces," as the main means of commercial and public transportation.

Indeed, by mid-century Cincinnati had become quite prosperous. "Cincinnati is a beautiful city," Dickens continued, "cheerful, and animated . . . with its clean houses of red and white." It had a serious, constantly developing cultural life by that time as well. Music was a passionate preoccupation, especially among the German population. A Haydn Society was formed as early as 1819, and in 1849 the first *Sangerfest* was produced; in 1857 a special building was erected for these grand festivities, where nearly 2,000 singers made up the chorus. By the end of the 1860s, the German inhabitants alone had twenty musical societies.

The visual arts, however, were slower in growth; yet Cincinnati did not lack patrons. Among them were Dr. Daniel Drake, a pioneer physician and educator who supported Audubon and Hiram Powers, and Nicholas Longworth, who tried to organize an Academy of Fine Arts as early as 1812 and whose granddaughter, Maria Longworth Storer, founded the Rookwood Pottery in 1880. Longworth, who also helped Hiram Powers, aided

Robert Duncanson, one of the foremost black painters of the nineteenth century. In 1828 Frederick Eckstein, a sculptor and native of Berlin, finally founded an Academy of Fine Arts in Cincinnati, the first of its kind in the West. This did not last, and not until the art department of the Ohio Mechanics Institute was founded in 1848 and, later, the McMicken School of Design in 1869 did the city have permanent art schools. By the early 1870s the McMicken School, later to become the Art Academy of Cincinnati, had some 300 students, among whom were Twachtman and Robert F. Blum.

Twachtman attended the Ohio Mechanics Institute while he worked at the Breneman window shade factory. Gradually he persuaded his family to allow him more time to study art and after 1871 transferred to the McMicken School, where he registered part-time in day classes and where, in 1874, he met Frank Duveneck (1848–1919), who was to have a profound effect on his career.

About that time Duveneck had returned to his native city from Munich and had brought with him an exciting new style and the experience of a professional European art school. Duveneck had studied with Wilhelm von Diez at the Royal Academy in Munich and had become friendly with Wilhelm Leibl, whose realist style encompassed Frans Hals and Gustave Courbet—a manner that Duveneck was to make all his own. The essence of Duveneck's painting and the secret of its popularity lay in his exceptional combination of the direct attack on the canvas, using a bold "modern" brushwork carried out in the mellow tones of an Old Master—a combination that was hard to beat. When he reviewed Duveneck's highly successful one-man show at the Boston Art Club in 1875, Henry James called it "the excitement of adventure and the certitude of repose." Further, this was a method of painting radically different from the smoothly finished canvases of the Düsseldorf and late Hudson River School styles then in vogue.

Frank Duveneck was something of a celebrity in the "Over-the-Rhine" district. Born across the river in Covington, he was also of German descent and a family friend of the Twachtmans. As such, and with some reputation already, he was probably influential in persuading them to allow Twachtman to pursue a full-time career as an artist. Twachtman worked with Duveneck, both at the McMicken School and at the latter's studio, which he shared with the painter Henry Farny and the sculptor Francis Dengler, until 1875, when Duveneck asked Twachtman to join him on his return to Europe.

Thus, in the fall of 1875, Twachtman embarked on the first major step of his career. He went to the Royal Academy of Fine Arts in Munich, where existing records indicate that *"Twachtman, John aus Cincinnati"* enrolled in *"eine Natur Klasse."*

Twachtman and Duveneck would probably have disembarked in Bremerhaven and then taken the train south to Bavaria through a Germany that was emerging as a unified state under Otto von Bismarck. A few years before Twachtman arrived, the 1,789 administrative and political units that made up the German nation were brought together and forged by the "Iron Chancellor" into the German Empire under Kaiser Wilhelm I. In 1870, after Bismarck had offered Bavaria certain rights of independence, Ludwig II—"Mad Ludwig," the king of Bavaria—offered the King of Prussia the imperial crown of Germany.

Bavaria today is the largest state of the Federal Republic of Germany. Its famous cities include its capital Munich, situated in the southeast not far from the Austrian border; Württemburg, to the east of Munich; and to the north, the ancient university town of Würzburg; Nürnberg, birthplace of Albrecht Dürer; and Bayreuth, home of the famed Wagner Festspielhaus, built in 1876 for the composer by his obsessive and erratic patron, Ludwig II, whose incredible fairy-tale pastiche of a medieval castle, Neuschwanstein, was under construction when Twachtman came to Bavaria. Actually, the whole area surrounding Munich was the concentrated essence of medieval and picturesque Germany—a fact that was not lost on the American artists who studied there. Munich was its center, politically, intellectually, and artistically.

The nineteenth century was the great fertile period for the arts in the history of Munich, beginning with the reign of King Louis I, who came to the throne of Bavaria in 1825 and was to transform the city into a brilliant cen-

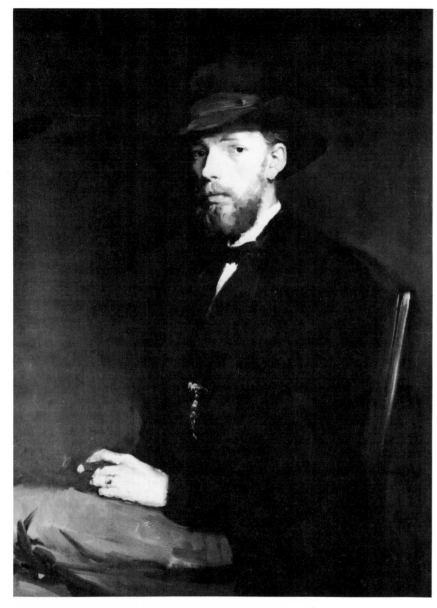

PORTRAIT OF PROFESSOR LUDWIG LÖEFFTZ, *ca. 1875 by Frank Duveneck, oil on canvas, 37 15/16" x 28 11/16" (96.4 cm x 72.8 cm) Cincinnati Art Museum (John J. Emery Endowment)*

ter of art and scholarship. This official patronage and encouragement continued during the strange and unhappy reign of Ludwig II.

Munich in this era was a city of art, of originality, of gay and gracious living; it was a peculiar combination of small-town life and *la vie bohème*, mingling sensuousness and creativeness. It was also an intellectual city, boasting some of the finest educational institutions in Europe at the time. It was one of the great artistic centers on the continent, a city where Twachtman could have visited the Alte Pinakothek with its superb collection of Old Masters and the largest, most distinguished collection of Rubens anywhere and the Bavarian State Museum, founded by Maximilian II and erected in 1867, which contains magnificent examples of German painting and decorative arts. And in Schwabing, the artists' and students' quarter near the Academy of Fine Arts, he would have had access to the University and the Bavarian State Library.

In short, it was a picturesque, stimulating, intellectual and artistic environment to which Frank Duveneck brought John Twachtman in 1875; Munich was "in" for American artists, for by the late 1860s it had replaced Düsseldorf as the art center of Germany. The German-born American artist Emanuel Leutze thought it was the best place for painters on the Continent, and the famous American art journal *The Crayon*, as early as 1858, had described the city as the "art capital" of Europe. Its Royal Academy of Fine Arts attracted numerous students eager to study with Karl von Piloty and Wilhelm von Diez, two of the more famous practitioners of the "Munich School." Although Frank Duveneck was the best-known American to study in Munich, among the first to arrive were David Neal in 1861 and Toby Rosenthal from San Francisco in 1865. Subsequently, a great many Americans were to study there, either at the Academy or privately with Duveneck, including William Merritt Chase, Henry Farny, Walter Shirlaw, Frederick P. Vinton, Julian Story, Thomas Dewing, J. Frank Currier, John W. Alexander, Joseph DeCamp, and Otto Bacher (who later wrote about Whistler in Venice).

Twachtman studied with Ludwig Löefftz, who became Director of the Munich Academy in 1891 and whose portrait was painted by his friend Duveneck about 1873. The most innovative contributors to the style of the Munich School, however, were centered around Wilhelm Leibl and his circle of younger painters, who worked outside the Academy proper. The painters of the "Leibl-Kreis," as they were called, were the major exponents of the "new realism" in Germany. Although their work reflects the influence of seventeenth-century Dutch and Spanish painting, it was clearly Gustave Courbet who had the greatest impact on these artists, whose ideas on realism were very close to that of the great mid-century French painter. Courbet himself was impressed by Leibl's work when he visited Munich in the wake of the First International Art Exhibition, which included some of the French artist's own pictures and which took place six years before John Twachtman registered at the Royal Academy.

Twachtman, like his compatriots Duveneck and William Merritt Chase, quickly adopted the dexterous approach of the younger Munich painters, and his pictures of those years were executed *alla prima*, or "all at once," in the broad brushstrokes of the dark "modern" Munich manner. *Head of a Man*, done in that way, is typical of his work during that period. More typical of the style, however, is Frank Duveneck's masterly *Portrait of Ludwig Löefftz*. The relaxed pose and calm, steady gaze of the sitter are in contrast to the directness and vigor of its presentation. Fresh, intense, and technically impressive in execution, the figure emerges from a dark background, producing an illusion of what Henry James called "palpable reality." This is the Munich style at its best, and it is no surprise that Duveneck had such an impact on his younger colleague from Cincinnati.

Twachtman studied in Munich until 1877, after which he went to Venice with Duveneck and Chase. Twachtman's Venetian paintings, though no longer the work of a student, do show the limitations of the Munich style. While they were probably painted *en plein air*, their somber tones are more Munich than Venice. Katherine Roof, a pupil and biographer of Chase, mentions in *The Life and Art of William Merritt Chase* that "even the inter-esting Venetian pictures painted by Chase and Twachtman have the darkness and tone of the interior subject, for the painter of that school did not see light and atmosphere."

In 1878 Twachtman sent two of his Italian landscapes to the first exhibition of the Society of American Artists, and in the same year, upon learning of his father's death, he returned to Cincinnati. His stay was brief, and from late 1878 until the fall of 1879, he could be found painting on the East Coast, in and around New York. At the latter date, circumstances brought him back to Ohio and a teaching job with the Women's Art Association of Cincinnati, the organization that would found the Cincinnati Art Museum a few years later. Also in 1879, on the strength of his entries in their second exhibition, he was admitted to the Society of American Artists.

At the end of the school year, in the summer of 1880, he was off again to the East Coast; then, in the autumn, to Florence, where he joined Duveneck's art school as a teacher. From there he and Duveneck and the latter's entourage, known as "the Duveneck Boys," went to Venice, where they met Whistler, licking his wounds after the famous Ruskin trial of 1877. He was then doing a series of etchings and pastels that had a great influence on the "Boys."

When the Duveneck school closed in 1881, Twachtman returned to Cincinnati and married Martha Scudder, daughter of a prominent Cincinnati physician, John Milton Scudder. Twachtman had met Dr. Scudder, who was himself an amateur painter, and his daughter at the studio of Toby Rosenthal in Munich. The newly wed Twachtmans prepared to leave Cincinnati for good, since Twachtman was convinced that Cincinnatians cared "little" for his paintings; he complained that the town was a very "old fogied place."

The Twachtmans sailed for Europe, where they visited England, Holland, and Belgium. In Holland he painted and etched with Julian Alden Weir, with whom he had developed a close friendship after their meeting in New York in 1879. But in 1882 Twachtman did return to Cincinnati to await the birth of his son, whom he named after Weir. During this stay in his native city, he painted dark, heavy landscapes in the nearby countryside. Finally, anxious to leave and dissatisfied with his work, Twacht-

man and his family sailed once again for Europe, this time headed for Paris, where he studied from 1883 to 1885.

*F*rance in the 1880s was the France of the Third Republic, but it was a France that had been radically changed during the Second Empire. Under Napoleon III there had been many social and administrative changes, but the most radical and impressive of these was the physical transformation of Paris itself. Beginning in the 1860s, the metropolitan area of the city was extended. The growth of industry and the ambitious replanning by Baron Haussmann had changed the city's character entirely. The emperor's program of spectacular public works included broad new boulevards and spacious parks, imposing churches and squares, the new Opera House, and extensions of the Louvre. He encouraged the opening of large new stores such as Bon Marché, Printemps, and Samaritaine and growth of the big banks such as Société Générale and Crédit Lyonnais. In fact, Paris became more than ever the economic, social, and cultural center of France. And Napoleon III did everything in his power to make it also the capital of Europe.

Certainly by the time Twachtman arrived in Paris it was the artistic capital, a position it was to maintain until well into the twentieth century. Between 1870 and 1900, there was an unbounded optimism and faith in progress, an intellectual ferment that was transforming the world of art and thought. Nowhere was the vigor and vitality of France's cultural genius shown to better effect than in the originality and experimentation of her painters and in the domination they established over European painting in these decades. As a result, students from every part of the world swarmed over Paris, and every French painter who gained prominence collected pupils and followers.

In 1883, Twachtman joined the many Americans who had chosen the French capital over other European cities as the place in which to study. By that time, the Barbizon School had been officially accepted and most of its practioners were dead; Monet had just settled in Giverny, where a few years later he was to attract a sizable following of Americans. Impressionism was then, publicly, nine years old and on its way to respectability. Yet most American painters who studied abroad were not very venturesome when it came to the serious artistic innovations of the day; in general, these earlier arrivals tended to cluster around the established institutions. Although Mary Cassatt allied herself with Degas and with her "little band of independents," as she called the Impressionists, and although Theodore Robinson became an early follower and friend of Monet, most of the American painters resident in France were, as Joshua Taylor put it, "audacious only within the limits of a stable tradition." And it was that stable tradition they wanted. Like Twachtman, they did not seek the avant-garde but came to learn their "trade," to absorb the French artist's professionalism. They sought professional training at the École des Beaux-Arts or at the Académie Julien, where Twachtman studied and where Boulanger and Lefebvre gave criticism. As an accepted adjunct to the official schools, Académie Julien provided studio space and hired the models as well as teachers to criticize. Drawing was the main activity there, since it was often too crowded to paint; and drawing technique was based on the rigorous French academic traditions descended from the Neoclassicists earlier in the century.

All of this approach suited Twachtman right down to the ground, for he had come to Paris to learn to draw. By now he had become largely dissatisfied with his work and disenchanted with the effects of his Munich training, the limitations of which he had begun to recognize. It was in this vein that he complained to J. Alden Weir in a letter from France: "I don't know a fellow who came from Munich that knows how to draw or ever learned anything else in that place." He immersed himself thoroughly in the discipline of drawing. Stanford White remarked that he "found Twachtman hard at work—drawing—slavery—I should think to him—but a slavery he will never regret—" The celebrated architect wrote to Weir, in May 1884, "He [Twachtman] is delighted with his life in Paris."

*I*n winter Twachtman studied at the Académie Julien, and in summer he painted in the Normandy countryside and in Seine-Maritime at Arques-la-Bataille, near Dieppe. He also worked in Holland, and his painting of that period reflects not only his training at Académie

Julien but, in his handling of the combination of diffuse light and precise draftsmanship, the influence of Jules Bastien-Lepage (1848–1884) as well.

Bastien-Lepage's draftsmanship and scientific study of values, his pleinairism, was an important influence on many American artists. He was considered in his time as "the author of a new departure," who had "the abiding virtue of sincerity," and Twachtman said of him (in a letter of 1885 to Weir, who was an ardent admirer), "What tasks the man did set himself in the painting of a white apron, with which he was as much in love as the face of a person." Soon after Bastien-Lepage made his appearance as a painter of peasant life, about 1878, it became evident that he was a plein-air painter to contend with. It was his work as a plein-air painter, his attempts to reconcile accurate draftsmanship with the atmosphere of outdoor painting convincingly, that interested Americans and became his particular contribution to art history. Some conservative critics even included him among the Impressionists. Richard Muther, in his *History of Modern Painting* of 1907, claimed that "All the forms and ideas of the Impressionists, which no one, outside the circle of artists, had been able to reconcile himself, were to be found in Bastien-Lepage, purified, mitigated and set in a golden style."

Obviously Bastien-Lepage was a middleman. His art was a matter of compromises, for which Muther himself coined the delightful term "amiable concessions." His most famous painting, *Joan of Arc*, demonstrates his attempts to combine the informality of pleinairism with the discipline of studio drawing. Along with the unfortunate literal inclusion of the "vision" behind her, the figure of Joan was very obviously posed and painted in the studio. It does not seem part of the landscape around it, a landscape that is lovingly observed and beautifully rendered.

It was this quiet observation of fact, and the "audacity within the limits of a stable tradition," which appealed to American artists, and the pictures Twachtman painted between 1883 and about 1888 reflect the plein-air legacy of Jules Bastien-Lepage. In them Twachtman eliminated the bravura brushwork and mahogany tones of the Munich style in favor of a more even application of paint and a subtler handling of diffuse overall light, through which he sought a more sensitive approach toward his subject matter. The composition, simplicity of concep-

JOAN OF ARC *by Jules Bastien-Lepage, oil on canvas, 100″ x 110″ (254 cm x 279.4 cm) The Metropolitan Museum of Art (Gift of Erwin Davis, 1889)*

tion, elegant placement of forms, and almost mono-chromatic color in these works also indicate the influence of Whistler and of Japanese art. In such pictures as *Springtime* and, especially, *Arques-la-Bataille*, there is an indication of Twachtman's growing interest in abstraction and the beginnings of a personal point of view.

These pictures painted with intelligence, sensitivity, and skill are the work of an assured, accomplished artist. Yet he was still dissatisfied; he was still seeking answers, his own way—a way that was to be found neither in realism nor in pleinairism. His feelings in the matter seem to be summed up in a criticism of Bastien-Lepage concluding the same letter to Weir in which Twachtman had praised the French artist: ". . . he seldom went beyond the modern realism which, to me, consists too much in the representation of things."

In the spring of 1885, John Twachtman ended his studies in Paris. It was time, and he had learned what he could at the Académie Julien, absorbed what he could from his contemporaries and from his visits to the Louvre. But his leave-taking was not contemplated without some trepidation. "If I must go home soon," he wrote to Weir in an undated letter around this time, "I hardly know what will take the place of my weekly visit to the Louvre. Perhaps patriotism, but my country shall always have that and the best possible paintre [sic] I can make of myself." Martha Twachtman and the children (a daughter, Marjorie, was born in Paris in 1884) went on ahead to Cincinnati while Twachtman stayed to paint in France and Holland during that summer and in Italy with Duveneck through the fall. He returned to the United States in the winter of 1885–1886.

The period immediately after Twachtman's return was a particularly rough one for the artist. In March 1885, a crate of his work done in France was lost at sea when the British steamer *Oregon* went down off the coast of New York. The oil paintings were salvaged, but it is probably that work of a more fragile nature was beyond saving. In addition, he ranged up and down the Northeast looking for support, and a letter to Weir from Canada in April 1886, asking him to look after his interests in the matter of the auction of his salvaged pictures, is an indication of Twachtman's situation at the time.

In the summer of 1886, Twachtman and his family were reunited and living in Greenwich, Connecticut, presumably with the financial help of Dr. Scudder. In September they moved to nearby Cos Cob, "to board for a while and hope that our credit is good there." About this time Twachtman managed to survive by painting, on a cyclorama in Chicago, one of those huge battle scenes, such as the Battle of Gettysburg that were very much in vogue then. He was part of a crew that included Arthur B. Davies, who painted "skies bursting with bombs and the lurid accompaniments of battle." Fortunately the task paid very well, and Twachtman was able to get on with his own painting.

He joined Weir in Branchville, Connecticut, and together they painted and explored that state. He also began to show regularly with the Society of Painters in Pastel. It was a medium that suited his temperament and his search for a personal style. He sent a group to the Society's exhibition in 1888, where he received favorable critical notice. In fact, in covering the show, *The New York Times* of May 5, 1888, went so far as to claim that "at least one of the pastels, *Grey Venice*, hardly yields to the best of Whistler and is better than many of the latter's."

Twachtman's pastels and, for that matter, his etchings are indeed wonderful examples of economy in color and line. Both qualities seem to have come from his stay in Venice and his contact with Whistler. *Boats on the Maas* is very Whistlerian in its delicacy of touch and its grasp of essentials with a minimum of detail. Although the Holland subjects were done earlier, between 1881 and 1883, they are among his finest, and the second state of this print was reproduced for wide distribution in 1888–1889 by C. Klackner, a New York fine art publisher. This reproduction proved to be very popular.

The composition of *Boats on the Maas* is similar to Whistler's *Fishing Boats*, a pastel for which he claimed to have devised a "new" technique. In *Fishing Boats*, Whistler employed four colors—black, white, blue, and yellow—on a special brown paper that in itself con-

stituted a fifth color. He was proud of this sensitive use of brown paper, which allowed him to make a complete statement with the utmost economy. "Don't you like that brown paper as a background?" he asked Mrs. Havemeyer. "It has value, hasn't it? But it sets the critics by the ears, you know they think I'm mad." Twachtman also used that technique in his own work in pastel, a medium that, in turn, had some effect on the technique of his later painting. The matte surfaces of many of his canvases and the delicacy with which the paint is applied, as well as his finely balanced use of open areas, might well derive from his long familiarity with the pastel medium, for which he was praised in his day. *Tree by a Road* is a lovely example of this aspect of his art.,

Also, in 1888, his painting *Windmills* won the coveted Webb Prize at the tenth annual exhibition of the Society of American Artists, to which he had sent seven oils. It was at this time that Twachtman began receiving recognition from the art community, and certainly from his peers. In fact, the years 1888–1890 might be considered the apex of Twachtman's popular career; that is, the pictures he painted in those years were his most appealing to the public. He now began to enjoy a certain amount of financial well-being and critical success. Things were going well for him in the late 1880s, but he was never again to achieve such popularity in his lifetime.

In Europe it was the era of the famous Exposition Universelle in Paris, bringing with it the construction of the Eiffel Tower. Also in Paris at this time, Monet exhibited his *Haystack* series. In New York, Twachtman and J. Alden Weir exhibited together at the Fifth Avenue galleries of Ortgies and Company, a show that was a financial success. In the autumn of 1889, Twachtman began his teaching career at the Art Students League of New York, whose staff then included William Merritt Chase, Augustus Saint-Gaudens, and for a time, Thomas Eakins. This position finally brought him a steady income, which was augmented by a stint of magazine illustrating for *Scribner's Magazine*, whose records indicate Twachtman illustrated articles and stories appearing in the magazine from 1888 to 1893. In 1894 he also began teaching at the Cooper Union in New York. Earlier, in 1888, he had bought a farm on Round Hill Road near Greenwich, Connecticut, where he was to paint his best-known pictures.

In 1894 Twachtman won a Temple Gold Medal at the Pennsylvania Academy of the Fine Arts, where he was a steady exhibitor, and in 1893, a silver medal at the World's Columbian Exposition in Chicago. It would appear from his activities in this period that he was at last achieving the recognition and success he sought, the realization of his ambitions, of his longing, as he had written to Weir in 1880, "to go in quest of fame and fortune." But he was still dissatisfied with his work as he continued to seek his personal point of view. It was an inner search that would only be realized for him after he settled on his farm near Greenwich.

It was a search that led him to French Impressionism, although Twachtman's adoption of that approach came about less from any direct French influence than from the example of his fellow American Theodore Robinson, who had studied with Monet at Giverny and whom Twachtman had first met in Paris. Robinson was a frequent guest at the farm on Round Hill Road in the late 1880s, and the sound of his asthmatic coughing and the odor of his medicated cigarettes soon became as familiar as his delicate touch and the intimacy of his painting. As exemplified in *Scene at Giverny*, his work is lyrical, poetic, and a little diffident. He was a master of the quiet intimate *vue*. How much Twachtman actually was directly influenced by Robinson is not known, but the poetic feeling in the work of both is somewhat similar, and by 1890 Twachtman was well on his way toward a modified and personal version of the French style. He was well on his way toward evolving his own point of view, without which no artist can be really unique and memorable.

In *Misty May Morn*, *Sailing in the Mist*, and *Winter Harmony*, for instance, Twachtman achieves a subdued and subtle poetry which extends beyond the particular method that conveys it. It is Impressionism, yes; but it is not the lush, bold, and gregarious painting of the French or of such compatriots as Childe Hassam or Frank Benson. Twachtman's painting is full of "contradiction and complexity." A myriad of brushstrokes, a manifold set of colors and tones, combine somehow to give the impression of great simplicity; or conversely, the rendering of a single tree or a pond or the glimpse of a small waterfall

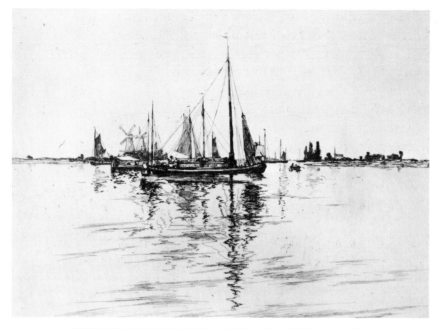

FISHING BOATS, HOLLAND *etching, Philadephia Museum of Art (Given anonymously)*

SCENE AT GIVERNY *by Theodore Robinson, oil on canvas, 16" x 25 ¾" (40.6 cm x 65.4 cm) The Detroit Institute of Arts (Gift of Mrs. Christian H. Hecker)*

reveals an absorbing complexity of ideas and feelings. His pictures are often indicative of a kind of "Less is more" philosophy; yet technically, they often embody the reverse as well.

John Twachtman was a landscape painter from the start, and the few figure pieces he did were not very successful. He was more comfortable painting from nature; his attitude toward it was essentially romantic and contemplative. Landscape, to him, was not just a motif, as it was to Monet and later to Cézanne. Twachtman was genuinely close to it; he was part of it. "To be isolated is a fine thing," he wrote to Weir in 1891, "and we are then nearer to nature. I can see how necessary it is to live in the country—at all seasons of the year." He never tired of using the same subject over and over, at different times and in different "seasons of the year," such as the nearby hemlock pool in autumn and the same scene in winter. Very often, he also painted the same scene at different times during the same season. Yet there is no sentimentality in his work; without clichés, his painting is gentle without being genteel. In fact, there is a certain detachment about his work, an objectivity that suggests a strong concern with the process of painting itself. Underneath all the subtle nuances lies a considered structure of some strength. *Sailing in the Mist*, which embodies those qualities with skill and sensitivity, also seems to express, through the image of the sailboat isolated in an indefinable space by mist, his own very personal contemplative philosophy.

The French Impressionist style is essentially outgoing, gregarious, full of bright and variegated color; more than any other style before it (and perhaps after it), it captured the vitality of *things*, of surface activity. The Impressionists painted, as William Dean Howells so aptly put it, "the smiling aspects of life." J. Alden Weir called it "a beautiful world." Despite the lively Impressionist technique, however, a mood of quietude does run through American Impressionism, as it does to a certain extent through all American painting of the nineteenth century.

In the nineties, however, this quietist strain in American painting took on almost the proportions of a movement in itself. Apparently inspired by Whistler's

"Nocturnes," such artists as Thomas Dewing, Dwight Tryon, Francis Murphy, and two American disciples of Whistler, Leon Dabo and Charles Rollo Peters, all subordinated other elements of their painting to the rendering of a certain mood or atmosphere. (The term "tonalism" was coined for this particular phenomenon by Wanda Corn in the exhibition "The Color of Mood: American Tonalism, 1880–1910," at the M. H. de Young Memorial Museum, San Francisco, in 1972.) In evoking this mood these artists, for the most part, painted the atmospheric effects of moonlight and morning mist, the waning day, and the mystery of fog. It dealt with feelings of nostalgia and reverie. In Europe a similar tendency was called *fin de siécle*, so the pervasive mood therefore was not restricted to American painting. The work of the French painter Eugéne Carrière comes to mind in this respect; even Monet painted a series called "Morning on the Seine," in which his subtlety of handling recalls that of Twachtman. Tonalism was a passing, fragile, and somewhat self-conscious approach, and strong painters such as Dewing and Twachtman, who used its effects, went beyond it.

Although Twachtman was concerned with atmosphere and nuance from the point of view of both tonalism and Impressionism, the abstract and austere silence, the mood of isolation, of loneliness even, so evident in Twachtman's work mark him as a man apart from his contemporaries. He was a philosopher, a man genuinely drawn to the contemplative life. Much of his work reveals that inward stillness and balance which is one of the main purposes of contemplation. It is as if he is saying that underneath life's struggle there is another and deeper life that continues independent of the struggle, survives it, and is not affected by it. Nevertheless, Twachtman was by no means an otherworldly person. His ambition was too strong; he exhibited regularly, and he cared about the status of the artist in America.

In 1893 Twachtman and J. Alden Weir exhibited with Claude Monet and Paul Albert Besnard at the American Art Galleries in New York. The critics talked of Monet's influence on the Americans but also pointed out that Twachtman and Weir had a style "they owe to no one but themselves." About 1894 Twachtman painted

a series of paintings of Niagara Falls on commission for Charles Carey of Buffalo, and about 1895 he executed a similar commission, this time of Yellowstone Park, for Major W. A. Wadsworth of the same city.

In 1897, Twachtman, Childe Hassam, and J. Alden Weir were instrumental in the formation of "The Ten American Painters," later known as "The Ten." This group of artists, deciding that the Society of American Artists was too large, too unwieldy, and too conservative, withdrew from that society to hold exhibitions of their own. Their shows were presented in installations similar to those pioneered by Whistler, in which each artist exhibited three or four of what he considered his best paintings. These painters, who in varying degrees of intensity shared an interest in Impressionism, included Edward Simmons, Edmund Tarbell, Joseph de Camp, Robert Reid, Frank Benson, Thomas Dewing, and Williard Metcalf. The Ten, whose first exhibition opened, appropriately, at the Durand-Ruel Galleries in New York in March 1898, also sought mutual advantage from pooling their efforts and shared a deep concern for the position of American art.

In February 1900, Twachtman had a two-man show with his son J. Alden at the Cincinnati Art Museum; about that time, too, he and his colleagues began painting in Gloucester, Massachusetts. The summers from 1900 to 1902 were spent working in that New England fishing village, and during that time his style began to exhibit further changes. His painting became less subtle, more direct; his color became more defined, his brushwork bolder. His overall approach began to take on a more openly expressive, almost Expressionist feeling, pointing tentatively in the direction pursued by his most famous pupil, Ernest Lawson. Unfortunately, Twachtman died before that direction might have been fully realized. It is fitting that his last exhibition, which opened at the Durand-Ruel Galleries, was afterward shown at the Cincinnati Art Museum in 1901. A year later he was dead.

These are the outlines of what appears to be a gradual and sure-footed climb toward a plateau of artistic excellence and material success. It was a success that seemed to parallel, in many ways, his professional development as an American Impressionist artist. Between the very beginning of his career and its abrupt termination, there ex-

ists a dramatic transformation from dark to light: from the somber tonality of Munich to the shimmering hues of Paris and exquisite light of Greenwich and Gloucester.

Still, these same general career outlines present a classic case of appearance versus reality: the appearance of statistics, of gold medals and of some external success, weighed against the reality of an inner search for a special point of view, poetical and personal, and of the artist's unceasing struggle to find it. For despite the silver medal in Chicago and the gold medal in Philadelphia (he was "a painter's painter," always admired by his fellow artists), his work was difficult to understand by the public-at-large, and he was not very well known in his lifetime. Edward Simmons, a fellow member of The Ten, remembers walking up and down Fifth Avenue with Twachtman, visiting all the dealers in a vain effort to sell one of Twachtman's landscapes. The critics were by and large complimentary, but his work did not sell. Twachtman himself summed up the situation. "You are studying art here now," he said in an address to students at the Art Institute of Chicago in 1893, "and someday some of you will become painters, and a few of you will do distinguished work, and then the American public will turn you down for second- and third-rate French painters."

Twachtman's search for his special point of view made him something of a dreamer. He was also ambitious, as expressed when he wrote to J. Alden Weir that he "longed to go in quest of fame and fortune"; yet he never succeeded. He was a classic case of the misunderstood artist, melancholy and bitter, and Weir responded to this aspect of his friend's character in his portrait of Twachtman done in 1894. In it, the sitter emerges from a somber background of almost total darkness, and the mood created is one of reflection and sadness.

By the time of Twachtman's death in 1902, almost everybody was an Impressionist. There was a genteel air about Impressionism by then. Its formulas had jelled and were being taught in art schools. "People like impressionism," said Gully Jimson, Joyce Cary's wonderful character in *The Horse's Mouth.* "Still do, because it hasn't any idea in it . . . because it's just a nice sensation, a little song. Good for the drawing room. Tea cakes. But I got tired of sugar. I grew up."

The inevitable reaction had set in. Nevertheless, Impressionism had introduced a new way of looking at the world, as well as a new world of color. "If," as Henry James remarked of American painting in the late nineteenth century, "we find a great deal of Paris in it," Impressionism did provide the framework for some intensely personal and individual styles.

Although Monet was a pervasive influence, John Twachtman's need "to live always in the country—at all seasons of the year" and his evocations of mood while contemplating a landscape in its changing aspects are closer in feeling to the poetic and philosophical subjectivity of a Chinese painter of the Sung period than to the almost scientific objectivity of Monet. Twachtman's art is conceptual and contemplative, rather than perceptual and active; yet it has undeniable strength. "The great beauty of design," Childe Hassam wrote in "John H. Twachtman: An Estimation," for the *North American Review* of April 1903, "which is conspicuous in Twachtman's paintings is what impressed me always; and it is apparent to all who see . . . that his works were . . . strong, and at the same time delicate even to evasiveness. . . ."

In the end, John H. Twachtman indeed found a style that he "owed to no one but himself."

Color Plates

"As the Young Frenchmen of 1830 profited by the example
of Constable . . . so will the coming landscape — men use
the Impressionist discoveries of vibration and the possibilities
of pure color, and while careful to 'hold fast to that which
is good,' will go on to new and delightful achievement."

— Theodore Robinson, 1892

"Dear Weir

. . . To-night is a full moon, a cloudy sky to make it
mysterious and a fog to increase the mystery. Just imagine
how suggestive things are. I feel more and more contented
with the isolation of country life. To be isolated is a fine
thing and we are all then nearer to nature. I can see how
necessary it is to live always in the country — at all
seasons of the year.

We must have snow and lots of it. Never is nature
more lively than when it is snowing. Everything is so quiet
and the whole earth seems wrapped in a mantle. That
feeling of quiet and all nature is hushed to silence.

I will see you again on Friday

Greenwich, Dec. 16, 1891 Twachtman"

Plate 1
HEAD OF A MAN, c. 1875–1877
Oil on board
14⁷/₁₆″ × 10¹¹/₁₆″ (36.6 cm × 27.2 cm)
Cincinnati Art Museum (Gift of Elsie Storz)

Encouraged by Frank Duveneck, with whom he went to Europe in 1875, Twachtman studied at the Akademie der Bildenden Kunste in Munich until 1877. Although he worked with the official teachers at the Academy and with Frank Duveneck, it was the German painter Wilhelm Leibl who best represented the progressive ideas of what has come to be known as the "Munich style." At that time Leibl had startled the art world of the Bavarian city with his radical way of painting the figure, a method based on direct observation and inspired by Courbet. When working on a portrait, for example, he began directly with a loaded brush, covering the canvas quickly with paint and boldly blocking in the large masses. He would build the head in light and dark tones, working up from a warm dark ground and treating textures with broad directional brushstrokes.

Even though somewhat tentative, Twachtman's *Head of a Man* follows the method promulgated by Leibl and his American admirer Duveneck. Twachtman later repudiated his Munich training, but it was the first major step in his evolution of a personal style and did give him a mastery of direct painting that was to last throughout his career.

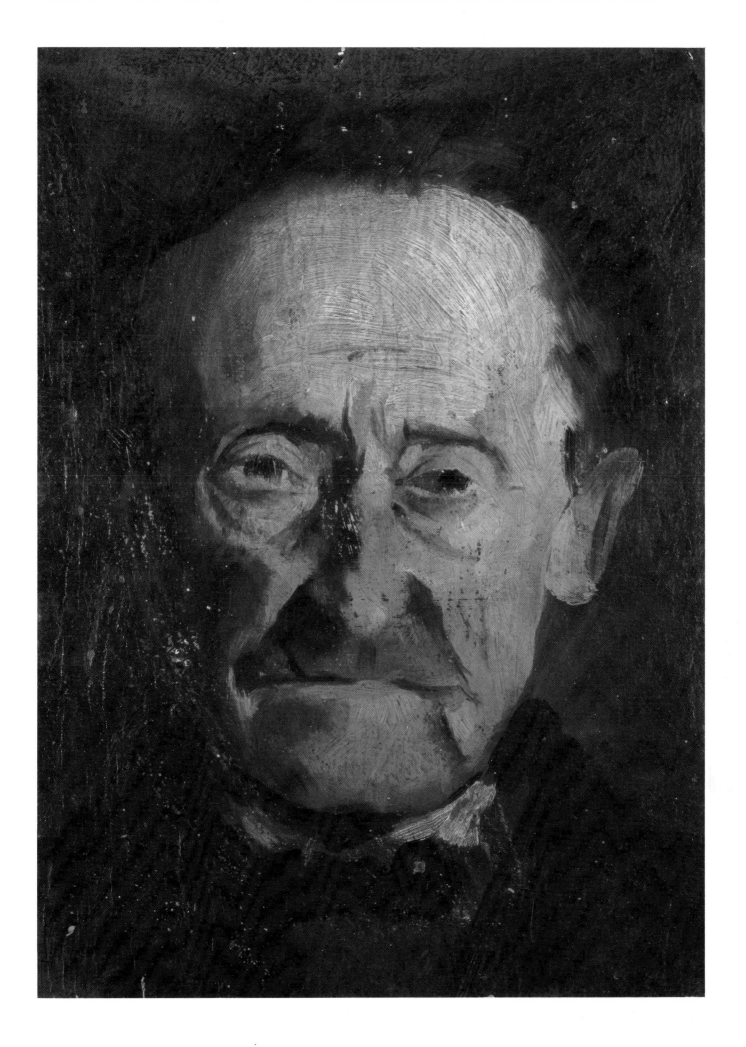

Plate 2
VENICE LANDSCAPE, 1878
Oil on canvas
12″ × 20½″ (30.5 cm × 52.1 cm)
Signed and inscribed: Venice '78
Courtesy of Museum of Fine Arts, Boston
(Bequest of Sarah Wyman Whitman)

In the Munich style the paint was applied heavily with an oily, fatty quality and in tones of black and brown. Although the technique was inspired by Courbet, the low-key color reflects an interest in the "time-darkened" tones of the Old Masters. This latter aspect is evident in Twachtman's work in Venice, where he, Duveneck, and Chase painted in 1877–1878.

Twachtman's Venice pictures do not have the superficial brio of Duveneck's work or of Chase, but they still are marked by what Katherine Roof called "the darkness and tone of the interior subject." Nevertheless, Twachtman always exhibited an innate restraint and did not allow the Munich style to replace direct observation—a fact that was noted by the critics in reviewing the pictures he sent to the Society of American Artists first exhibition in 1878. In March 1878, the critic of the New York *Daily Tribune* wrote: "Mr. Twachtman's Venetian studies . . . all show a certain verity extremely valuable after the stage-play of the general run of artists who take Venice in hand." From such critical comments, it was equally obvious that Twachtman was not unduly carried away by the picturesque qualities of "La Serenissima." *Venice Landscape* also reveals his penchant for painting the "quiet corners" of subjects that interested him—a penchant he would develop more fully later on.

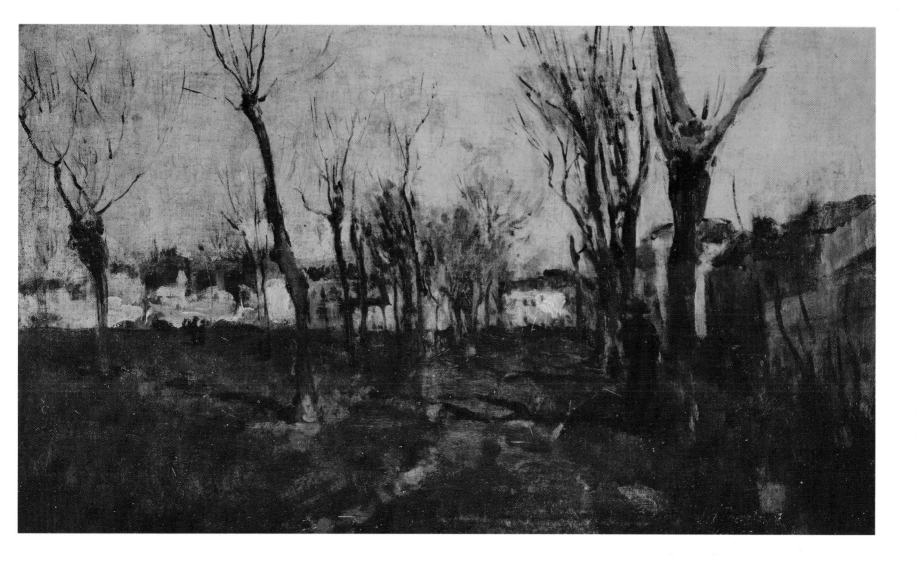

Plate 3
NEW YORK, HARBOR, c. 1879
Oil on pressed board
8¹⁵/₁₆″ × 12¹/₁₆″ (22.7 cm × 30.6 cm)
Cincinnati Art Museum
(Bequest of Mr. & Mrs. Walter J. Wichgar)

In 1879–1880, Twachtman divided his time between Cincinnati, where he had a teaching job, and the East Coast. Paintings such as *New York, Harbor* still carry the stamp of the Munich School; yet *The New York Times* of March 26, 1880, reported of his work during this period: "He has an excellent feeling for the look of water near ships and docks, and . . . the glint of light . . . on the smooth water about shipping." Twachtman restlessly drifted from New Jersey to Massachusetts. "During all of my stay east my movements were so sudden and frequent," he wrote to J. Alden Weir, in September 1880, "that I stayed but a short time at one place," then adding "I am . . . anxious to see you, which I expect to very soon. About a month ago Duveneck wrote me from Italy and offers me certain inducements to join him at Florence, where he has sort of a private school and in which I am to teach."

In that same letter to Weir, with whom he developed a close friendship, Twachtman revealed his optimism (at the time), his romanticism, and his driving ambition—personal qualities which were then ahead of his work. "You do not know how tempting every opportunity is to me and how I long to go in quest of fame and fortune. . . . In my mind I have finer pictures than ever before. Ten thousand pictures come and go everyday and those are the only complete pictures painted, pictures that shall never be polluted by paint and canvas."

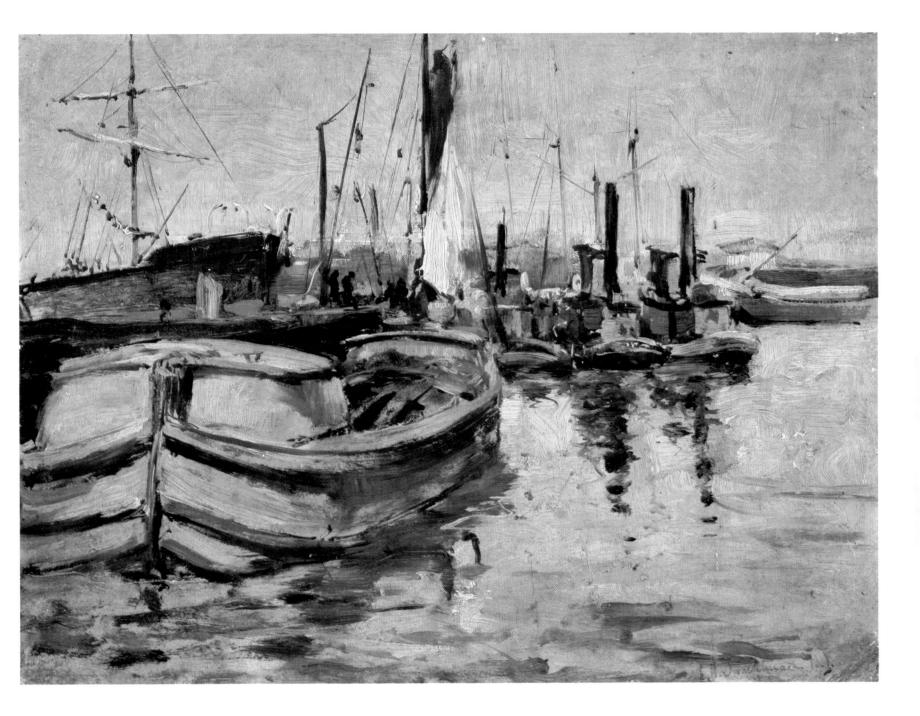

Plate 4
WINDMILLS, DORDRECHT, c. 1881–1884
Oil on panel
14½″ × 20½″ (36.8 cm × 52.1 cm)
Signed
Charles and Emma Frye Art Museum, Seattle, Washington

Much of Twachtman's work is not dated, and it is often difficult to pin down an exact date for a great deal of it, without adequate documentation. In this picture, for example, the color and tone, the lightness of it, could have come from his stay in France, during which time he also painted in Holland. On the other hand, the inclusion of realistic detail and the quality of the brushwork argue a lingering influence of the Munich style as well. Nevertheless, the indication of an immense sky and the feeling of large open space in this beautiful painting clearly reveal Twachtman's response to the Holland landscape he first visited in 1881 while on his honeymoon.

In that year, the Twachtmans sailed for Europe, stopping first in England, then in Holland, where they painted and etched with J. Alden Weir and his brother John. (Mrs. Twachtman was also an artist and frequently exhibited with her husband at the New York Etching Club.) In Holland they met Anton Mauve; and in Belgium, Jules Bastien-Lepage, a friend of J. Alden Weir who was later to have a great influence on American artists, including Twachtman himself for a while.

The artist evidently had good feelings about his work in the Dutch countryside, for he wrote to Weir after his return to Cincinnati in 1882 that "the Holland work remains the best." By this time, certainly, his work had taken on the assurance of a professional, albeit a professional constantly working toward a personal point of view. In his mind, he continually sought a way to realize "finer pictures than ever before." He continued this search in Cincinnati, to which the Twachtmans had returned to await the birth of their first child.

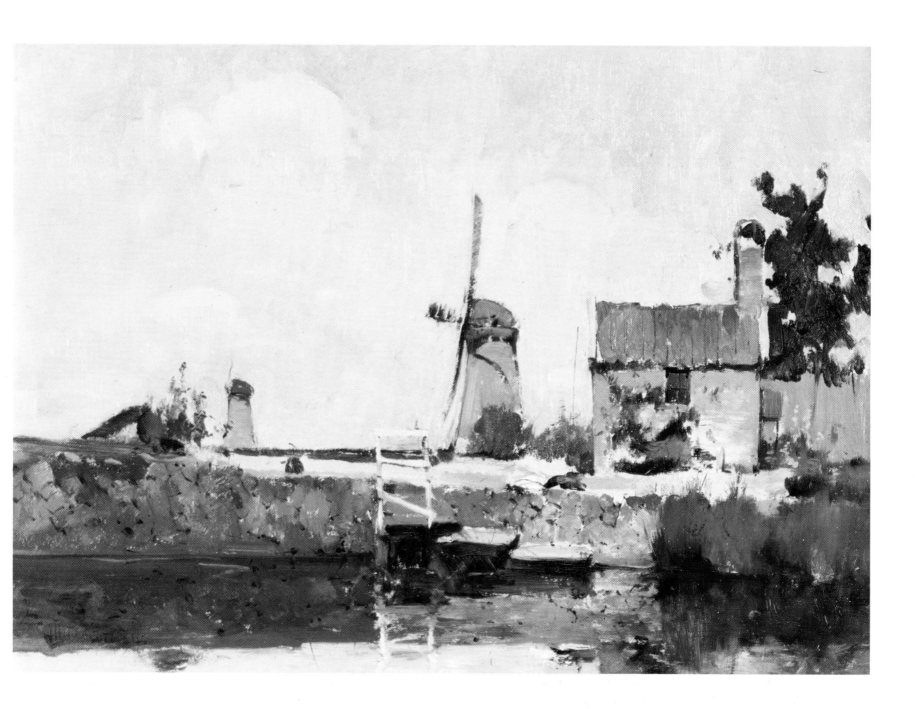

Plate 5
LANDSCAPE, c. 1882
Oil on canvas
35" × 46" (88.9 cm × 116.8 cm)
Munson-Williams-Proctor Institute, Utica, New York

"Yesterday I sent you my work, which has very little new in addition to what we did in Holland," Twachman wrote to Weir in 1882 from Avondale, a suburb of Cincinnati. "On some of these," he said, "I worked but I feel that nearly all, at any rate half of them, should have more work. . . . Some of my earlier work is better as regards unity and these last are more like studies. Write what you think of them."

There is no record of Weir's reply, but the critics of the day reflect the status of Twachman's work at this time, and perhaps echo his own dissatisfaction, too, as when the *Times* of February 6, 1882, remarked, " . . . Twachman seems to be first where he was two years ago." Twachman spent 1882 painting landscapes around Cincinnati which, like this picture, are for the most part workmanlike, competent, but relatively uninspired. This canvas does recall Courbet and suggests an attempt to shuck the skin of the Munich School. The impasto is not so heavy, the technique here does seem to point toward the more fluid pictures of his upcoming sojourn in France. He was, by his own admission, in the doldrums. "One naturally falls into a state of doing nothing out here," he wrote to Weir.

Once his son was born, Twachman became impatient to leave Cincinnati and complained to Weir that "a good many people, all of them supposed to be up on art matters, have seen my paintings, but I am convinced they care little for them. . . . There is no good art influence here and I shall be glad to leave. We will go either to New York or abroad. The latter is probably the best thing to do, and then I can study independent of everything."

Finally, anxious to leave, dissatisfied with his work and its public reception, Twachman and his family sailed for Paris, where he studied from 1883 to 1885. This move was the second major step in his career.

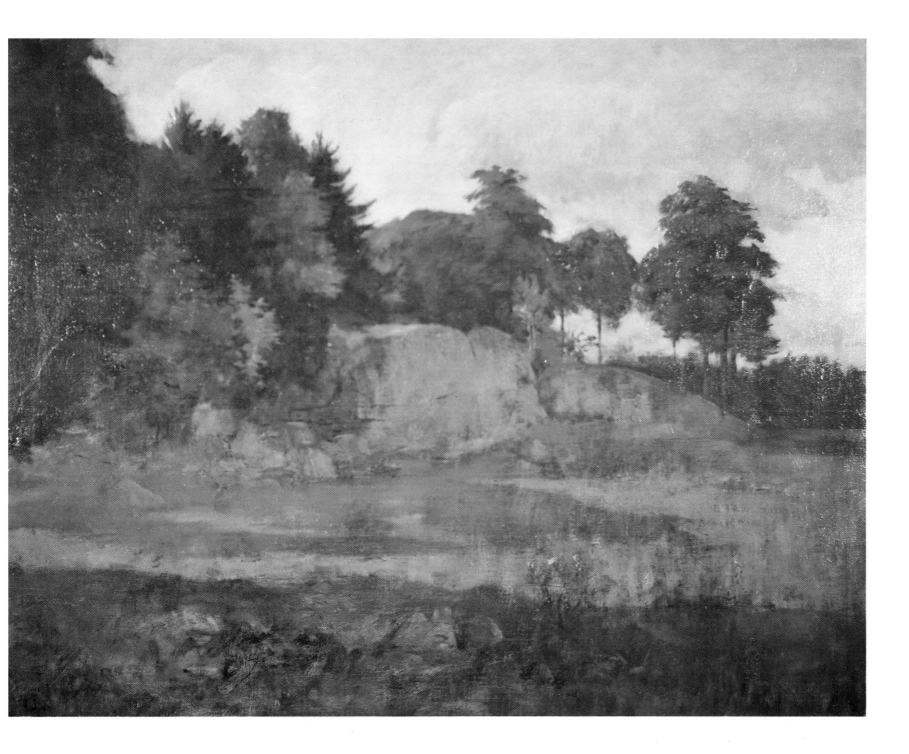

Plate 6
MOUTH OF THE SEINE, c. 1883–1884
Oil on canvas
26¾" × 20" (67.9 cm × 50.8 cm)
Signed
The Telfair Academy of Arts and Sciences, Savannah, Georgia

Although this painting is executed with a certain amount of vigor, it is a vigor that seems to hark back to Munich. There is a general air of awkwardness about it. Its composition is reminiscent of *New York, Harbor*, and despite the assured manner of applying paint to the canvas, there is something awkward in the placement of forms. There is a leaden, heavy atmosphere, reflecting an artist striving to change his style—also, perhaps, an indication of his state of mind at the time.

In a letter of December 7, 1883, Twachtman complained to Weir: " . . . the only thing I have sold since the spring was the green landscape to Mr. Davis. I believe I shall have to appoint you my sole and everlasting agent; no one else cares a damn for my things."

Twachtman's trip to France was apparently underwritten by his father-in-law, who also evidently made some suggestions about settling down in Cincinnati. "The old gentleman wrote from Cincinnati the other day," Twachtman whined to Weir, "that unless something turned up we should have to make that hog-sticking city our home."

Nevertheless, he soon appeared to pull himself together and wrote to Weir he was "drawing from the figure, nude, this winter, and you know how much I need drawing." The drawing he needed was supplied at the Académie Julien, where the Academicians Boulanger and Lefebvre were the principal critics. They insisted on a severely disciplined, vigorous, tight style of draftsmanship inherited from the French Neoclassic school of the early nineteenth century. In addition to his study *chez Julien*, Twachtman worked in the Normandy countryside at Honfleur and Arques-la-Bataille, near Dieppe in the Seine-Maritime, where *Mouth of the Seine* was painted.

Plate 7
SPRINGTIME, c. 1884–1885
Oil on canvas
36⅞" × 50" (93.6 cm × 127 cm)
Cincinnati Art Museum (Gift of Frank Duveneck)

Springtime, which was given to the Cincinnati Art Museum by Frank Duveneck in 1908, represents not only a shift toward a more personal style but also a final break with the bravura brushwork of the Munich style.

This picture reflects his attempt to combine the disciplined Académie Julien draftsmanship with the atmosphere of plein-air painting. To this purpose he was aided by the example of Jules Bastien-Lepage, whose contribution to the history of art was indeed his attempted reconciliation of these two opposite approaches—an opposition that proved ultimately irreconcilable. Bastien-Lepage tried to keep a foot in both camps, thus causing Degas to call him "the Bouguereau of the modern movement."

The American artists studying in Paris, however, felt otherwise. "All the younger men are mad on B. Lepage," Twachtman commented to Weir, "and say that he is the greatest of modern masters and compare him to Holbein. . . ." Twachtman himself took neither extreme position. Mainly he admired Lepage's professionalism and dedication. "What tasks the man set himself," he said, "in the painting of a white apron," which seemed just as important to him as "the face of a person." Twachtman thought his *Joan of Arc* was "truly poetic" but, by and large, felt Lepage's work consisted "too much in the representations of things."

Twachtman himself was headed in another direction; his main concern was less one of reconciling two opposing elements than of using these elements as material in making and developing a personal style. The solution of this problem was to lead him away from realism and toward abstraction. In *Springtime*, as in the other pictures he painted during this period, he used his experience of drawing to *create form* rather than to *describe* an object: to create something according to his inner eye, his personal vision, rather than from direct observation of nature. He now favored a more even application of paint and a more diffuse overall light, with which he sought a more sensitive approach to his subject matter, more in accord with his personal point of view.

Plate 8
ARQUES-LA-BATAILLE, 1885
Oil on canvas
60" × 78⅞" (152.4 cm × 200.4 cm)
Signed and inscribed: Paris 1885
The Metropolitan Museum of Art

"I took a month from school this winter and painted a large canvas for the Salon," Twachtman wrote to Weir in an undated letter from Paris. The "large canvas" was *Arques-la-Bataille*, one of the largest and most beautiful pictures he ever painted, a fitting culmination to the French phase of his work. To his keen disappointment, it was rejected by the jury for the Salon. However, it is not hard to understand why. Notwithstanding its large dimensions (especially designed to be seen in a Salon exhibition), its point of view is detached and unsentimental; it tells no story beyond the stability and serenity of that particular landscape. It is about painting itself, and about the contemplative nature of the artist himself. It was a quiet corner of the world that Twachtman painted, and it was a quiet corner of the world he created. The use of strong horizontals indicating stability is reinforced by the almost monochromatic color scheme of silvery grays and greens.

If Twachtman's paintings of this period owe a lingering debt to the pleinairism of Bastien-Lepage, their composition, with a deceptive simplicity of conception and elegant placement of forms, also recalls the combined influences of Whistler and Japanese art. Such Oriental refinement is especially evident in the positioning and treatment of the clumps of weeds in the foreground of *Arques-la-Bataille*. In Twachtman's work of this time, there is indication of a growing understanding of abstraction and the beginnings of a personal viewpoint.

The work done by Twachtman between about 1884 and 1889 is painted with assurance, intelligence, and skill. It was popular as well. Despite his rejection by the Salon, the work he brought back from France and exhibited in the United States won him recognition and medals. He even managed to sell. *Arques-la-Bataille* was popular then, and it is popular still.

Nevertheless, Twachtman continued to search, continued to seek a style compatible with his private vision. After 1889 his work underwent another change in style, and he was never again to be as popular in his lifetime.

Plate 9
OLD HOLLEY HOUSE, COS COB, c. 1890–1900
Oil on canvas
25$\frac{1}{16}$″ × 25$\frac{1}{8}$″ (63.7 cm × 63.9 cm)
Signed
Cincinnati Art Museum (John J. Emery Endowment)

"We go to Cos Cob tomorrow," Twachtman wrote Weir in the fall of 1886, "to board for a while and hope that our credit will be good there."

Twachtman was referring to the Holley House in Cos Cob, Connecticut, where he and his family stayed until he purchased his farm on Round Hill Road, Greenwich. Twachtman and Weir also conducted their summer classes in that area, and Twachtman would stay there whenever his family was away. The owner, Josephine Holley, ran a boardinghouse for artists and writers, and her daughter Constant married Elmer MacRae. In addition to Twachtman, Mrs. Holley's guests included J. Alden Weir, Childe Hassam, and the writer Lincoln Steffens, who described the house and its guests in his *Autobiography*.

Twachtman, like Hassam, painted the place several times. In *Old Holley House, Cos Cob*, he not only renders a portrait of the house but depicts it during one of his favorite seasons—winter, after a heavy snowfall. ("Never is nature more lovely than when it is snowing. Everything is so quiet and the whole earth seems wrapped in a mantle.") It was this silence and serenity which interested him, "that feeling of quiet" he expresses so effectively in this picture.

All his skills are brought to bear in realizing that expression. The quiet tones, the subtle modulations of color, the strong horizontal of the house and the vertical of the tree that serves as both foil and focus for it, are all meant to convey the idea of silence and, oddly enough, of solidity. Even the use of a square canvas, an immovable and stable form, serves the artist's purpose. The square, or near-square, canvas was a format Twachtman was to use quite often, just as he was frequently to use white as a color. The latter trait was one he shared with Whistler, and his handling of this problem in *Old Holley House* is akin to Whistler's in *The White Girl* (National Gallery, Washington, D.C.).

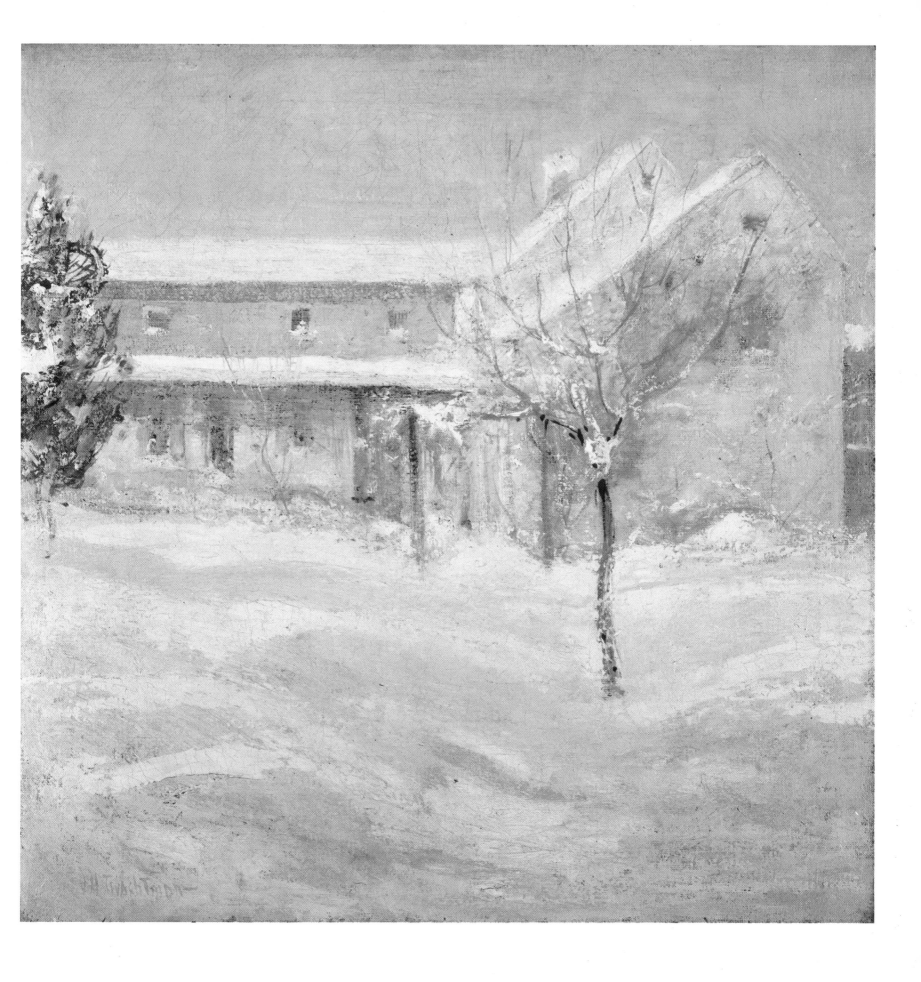

Plate 10
HEMLOCK POOL (AUTUMN), c. 1890–1900
Oil on canvas
15½″ × 19½″ (39.4 cm × 49.5 cm)
Private Collection, Philadelphia

Twachtman was a regular exhibitor in the annual exhibitions of the Pennsylvania Academy of the Fine Arts, and at the 64th Annual in 1894 he won a Temple Gold Medal for a picture entitled *Autumn*. The conservative *Philadelphia Press* was upset that such an important award should go to a "small impressionist picture," and both the *Philadelphia Inquirer* and the *Sunday Times* still regarded the style as only "experimental" and "a passing fancy."

There is no indication, however, that this particular canvas was in fact the one awarded the gold medal. Twachtman painted this subject many times, and "in all seasons of the year." The locale is the hemlock pool situated on the seventeen-acre farm Twachtman bought in 1889. He painted aspects of it—*Hemlock Pool, Horseneck Falls, The White Bridge*—again and again, in a series reminiscent of Monet that depicted the changing seasons and times of day.

This autumn picture is something of a discovery; it had not been shown or published until quite recently. It can readily be understood why it might have upset the critics of its day, especially the conservative ones, for the painting comes very close to abstraction. Its autumn colors are not blatant; their reticence and nonpicturesque quality express a quiet mood and emphasize the underlying unity of the structure, its "allover" feeling. In regard to Twachtman's work in series, the vantage point from which it was painted and the subject matter are the same as those in the following illustration, *Winter Harmony*.

Plate 11
WINTER HARMONY, c. 1890–1900
Oil on canvas
25¾" × 32" (65.4 cm × 81.3 cm)
Signed
The National Gallery of Art, Washington, D.C.
Gift of the Avalon Foundation

If the preceding plate, *Hemlock Pool (Autumn)*, reflects the quieter aspects of one of nature's most colorful seasons, so also does Twachtman treat the more pleasant side of winter snow. Using white as the key color, he relates all other color accents to it. By building on an underlying structure of verticals and horizontals; by sensitive use of grays and grayish greens, browns, and blues; and by a careful balance of warm and cool tones, he makes *Winter Harmony* into an appreciation of the overriding silence and solitude of a winter's day in the countryside.

This picture is Whistlerian in feeling, and even its title recalls Whistler's use of musical terms as titles for his paintings. But it is the carefully orchestrated use of white and the equally careful modulation of tone in this painting—as well as in *Old Holley House* (Plate 9) and *Snowbound* (Plate 24)—that are reminiscent of Whistler's manner. This was an aesthetic problem which intrigued the great expatriate over the years, and he once said that Canaletto "could paint a white building against a white cloud. That was enough to make any man great."

On the other hand, although Twachtman's *Winter Harmony* reveals a concern for the use of white as a color,

and although its mood of hushed silence is close in feeling to some of Whistler's "Harmonies," it is more than an arrangement of color and form for their own sake. In Twachtman's work aesthetics finds its place within the general context of a romantic, philosophical, and contemplative attitude toward the landscape as a subject. One of his most beautiful paintings, *Winter Harmony* is one of his most sensitive responses to the changing moods of nature. And he did respond differently and individually each time: a varying response seen in his approach to the same or similar subjects during the seasonal changes captured in the sequence in which the color plates are arranged here.

By now he had found his style, his personal point of view. In a modified form of French Impressionism, influenced by Monet but deriving more from the work of his friend Theodore Robinson, Twachtman had developed the vehicle that, on his terms, could successfully carry his ideas. With this responsive, mutable style he could maneuver his impressions of and his reactions to nature with skill and flexibility—and now hard and bright, as the following plates will show.

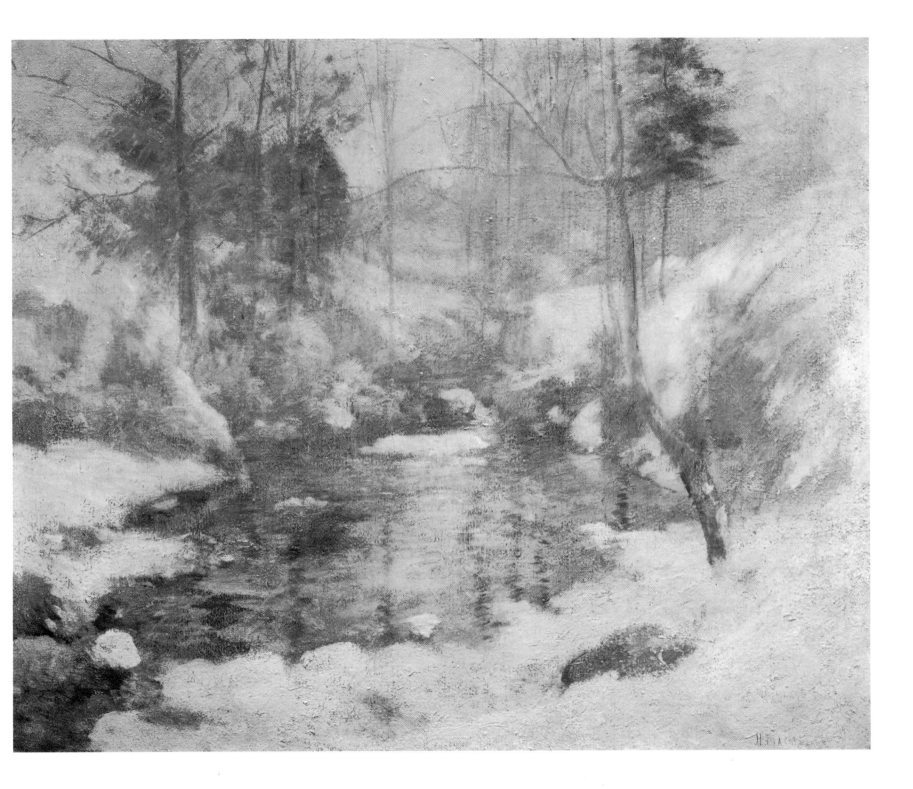

Plate 12
WINTER, c. 1890–1900
Oil on canvas
21½" × 26" (54.6 cm × 66 cm)
Signed
The Phillips Collection, Washington, D.C.

This painting could also be called "Waiting," capturing as it does the height, or depth, of winter—stark, austere, and cold. There is no "mantle of snow" here to cover the spiky forms of leafless trees or modify the unrelieved severity and barrenness of the scene. There is a pervasive stillness and silence, with no indication of wind to counteract forms that appear frozen in attitudes of waiting without expectation—not at all like the promise of the hour just before dawn or the hushed expectancy in a theater just before the curtain goes up. There is a bleak, almost wasted landscape. It is indicative of Twachtman's sensitivity to the moods of nature, and of his own personality, that he could take this essentially forbidding and somewhat depressing subject and translate it into visual poetry.

Plate 13
END OF WINTER, after 1889
Oil on canvas
22" × 30⅛" (55.8 cm × 76.3 cm)
Signed
National Collection of Fine Arts,
Smithsonian Institution, Washington, D.C.

Embodied in *End of Winter* is the positive feeling of expectancy lacking in *Winter*. There is a sense of life, of incipient movement. The clear air reveals the house in the background, which seems to be surveying the changing scene before it and at the same time gives the picture scale and distance. Quietly, along with its inhabitants, it waits for the onset of spring implied in the soft warm color and the gradual disappearance of snow from the surrounding landscape.

This is an entirely different treatment of the scene; technically, the dominant idea is realized by the use of deep space, as opposed to the frontality and shallow space of *Winter*. The implied shrinking action of the melting snow is accompanied by the strong diagonal of the stream that zigzags from the foreground to the road and house in the background, subtly pulling the eye back into the distance and from one side of the painting to the other. At the same time the trees create a varied pattern of forms over the surface of the canvas. This is a masterful picture painted by an artist whose control of his style enables him to express and to realize his ideas to their fullest, one who demonstrates an extraordinary response to the natural world in the same moment that he creates his own.

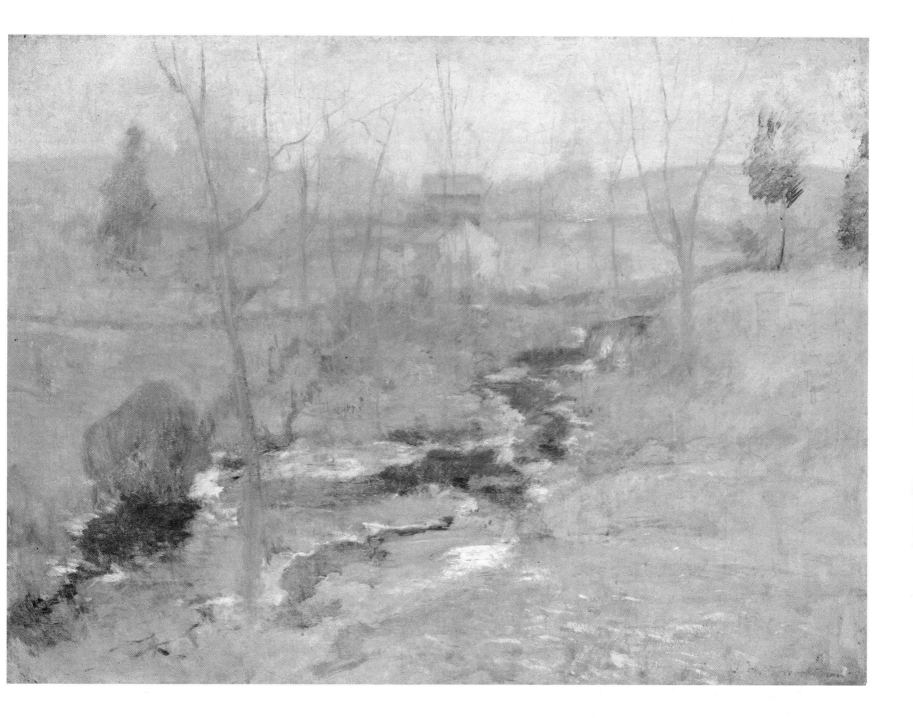

Plate 14
MISTY MAY MORN, 1899
Oil on canvas
30" × 25⅛" (76.2 cm × 63.8 cm)
Signed and dated
National Collection of Fine Arts,
Smithsonian Institution, Washington, D.C.
(Gift of John Gellatly)

From approximately the same vantage point as *End of Winter* but a little closer in, the hemlock pool and the stream that feeds it are here viewed covered, not with a mantle of snow and exposed to the rigors of winter, but with the chromatic foliage of spring. The same boulder as in the lower left of the preceding picture, there stark and austere in the light of winter, now has its contours softened and almost obscured by the mellow luminosity and emerging foliage of an early spring morning. In response to the new season and sensitive to another mood, Twachtman's palette has undergone an obvious and significant change. There is brighter color here—yellows, greens, shimmering blues—as an early morning in May is rendered in all its freshness and delicacy.

The composition of this picture is somewhat reminis-cent of Monet's paintings of the poplars along the river Epte near Giverny, but perhaps is even more reminiscent of a group of paintings Monet called his "Morning on the Seine" series, painted in 1897. These paintings show a shared moment when two artists, one French and one American, working several thousand miles apart, were each pursuing a common goal that resulted in an evoca-tion of a special atmosphere and mood (for examples of this series by Monet, see the exhibition catalogue *Monet's Years at Giverny: Beyond Impressionism*, The Metropolitan Museum of Art, New York, 1978). It was an atmosphere represented in the kind of painting for which Twachtman was both praised and criticized, a poetic aura that was also very much a part of the end of the nineteenth century.

Plate 15
SPRING MORNING, c. 1890–1900
Oil on canvas
25″ × 30″ (63.5 × 76.2 cm)
Signed
Museum of Art, Carnegie Institute, Pittsburgh, Pennsylvania

In *Spring Morning* Twachtman shifts his point of view to another part of the hemlock pool, and to a frontal composition that is naturalistic yet very abstract at the same time. The spatial suggestions of the upper curve of the pool and the recession achieved by the placement and diminishing size of the trees in the background are offset and counterbalanced by the strong surface pattern created by the assertive reflection on the pool in the foreground.

Although Twachtman's mental image here might relate to visual ambiguity (Which is reality—the landscape or its reflection?), the actual execution of the picture, with its direct frontality and strong surface pattern, is far from ambiguous and demonstrates Twachtman's exceptional ability to allow his form to follow the subject.

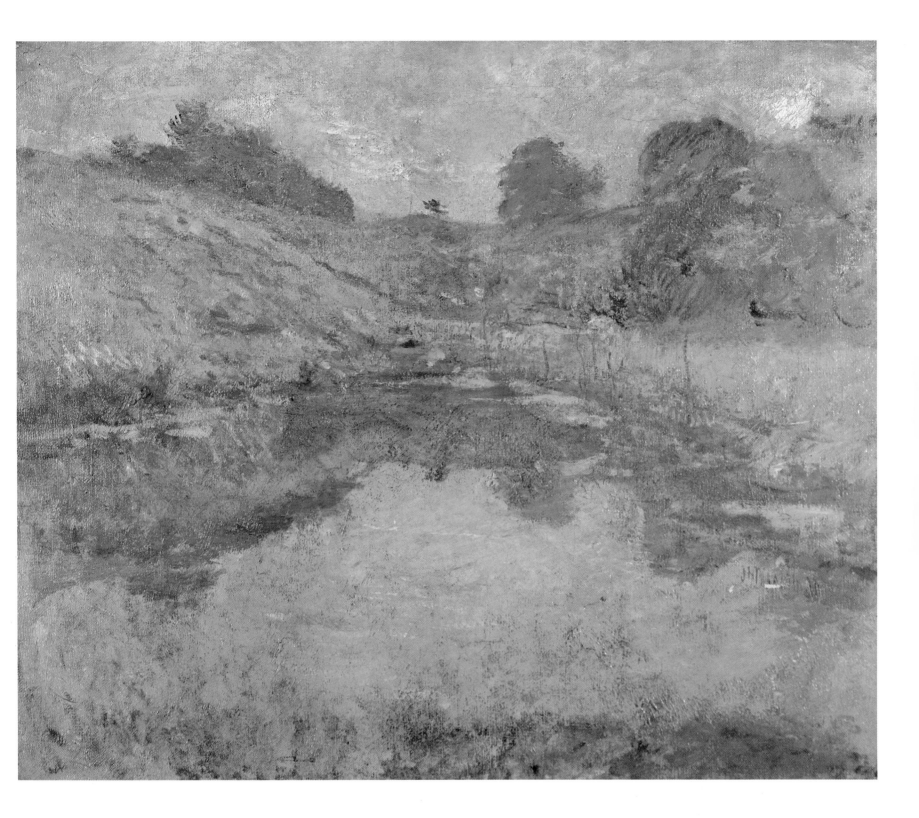

Plate 16
MEADOW FLOWERS, c. 1890–1900
Oil on canvas
33¼″ × 22¼″ (84.4 cm × 56.5 cm)
Signed
The Brooklyn Museum, New York
(Caroline H. Polhemus Fund)

"The weather," Twachtman wrote to Weir in 1892, "continues very fine. . . . The foliage is changing and the wild flowers are finer than ever. There is a greater delicacy in the atmosphere. . . ."

For painting this "greater delicacy" in *Meadow Flowers*, Twachtman had chosen an extreme close-up and a shallow background, thereby evoking a feeling of directness and immediacy. It is almost as if he were involving the viewer with the sense of touch as well as sight. Such "up-front" focus abstracts and isolates the subject from its conventional background, either as landscape or as a still-life vignette. Yet, within this somewhat unconventional approach, the flowers are painted with a delicate feathery touch which renders their essence marvelously and which is wholly appropriate to their nature.

It was characteristic of Twachtman that he was able to find his subjects almost everywhere, usually in the most modest and undramatic circumstances. Like his good friend Theodore Robinson, Twachtman was a master of the intimate *vue*; but he was also capable of a powerful visual statement, as evidenced in the next illustration, *The Pool*.

Plate 17
THE POOL, c. 1890–1900
Oil on canvas
26" × 31" (66 cm × 78.7 cm)
Signed
The Detroit Institute of Arts, Detroit, Michigan
(Gift of Charles L. Freer)

In contrast to the delicate, feathery touch of *Meadow Flowers, The Pool* is painted with great directness and vigor. Similar in concept to *Spring Morning* (Plate 15), this picture is much stronger than the latter: its color is more definite, and the impasto heavier. The grouping of the trees and the boulder—which appears in the lower left of *End of Winter* (Plate 13) and *Misty May Morn* (Plate 14) and again, in a different manner, in *A Summer Day* (Plate 26)—is not unlike the careful disposition of elements in a still life.

The device of the assertive vertical created by the tree and its reflection recalls that used by Monet in his poplar series painted in the early 1890s. Indeed, the boldness of *The Pool* is reminiscent of Monet's work. The color in Twachtman's painting, however, is not as strong or as daring in its contrast and brightness of hue; nor is his application of paint as sensuous as that of Monet.

The differences perceived between Monet and Twachtman can be said to represent the differences between French and American Impressionism in general. American Impressionism was never as bold, as lush, or as sensuous as its French counterpart; it lacked the same feeling for the *métier*, for painting for its own sake. The American version was generally more object-oriented and more conservative perhaps—certainly more reserved. There is a strain of what E. P. Richardson calls "quietism" in the American painting of that period. American landscape painting tends to be idealistic, even romantic. In it, nature is not just a *motif*; there was a definite attitude toward the natural world, akin to a religious and/or philosophical feeling, imbued in American landscape painting since the days of the Hudson River School. No other American painter of the late nineteenth century better expresses, or puts to better use, the restraint and the philosophical, contemplative tendencies characterizing the tradition of American landscape painting than John H. Twachtman.

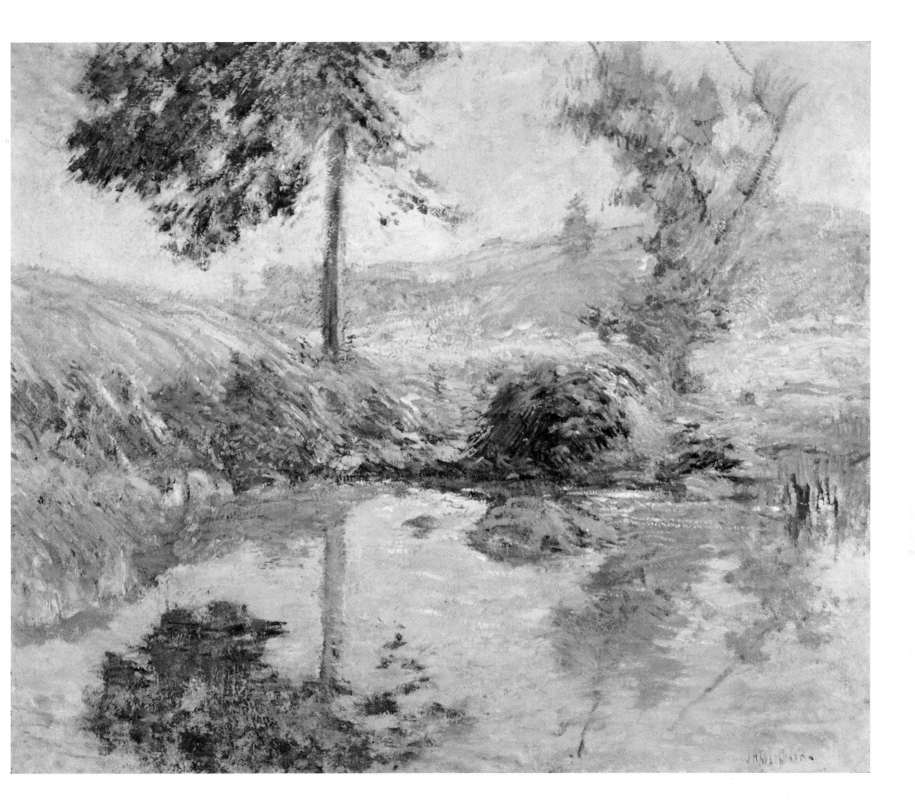

Plate 18
SAILING IN THE MIST, c. 1890–1900
Oil on canvas
30½″ × 30½″ (77.5 cm × 77.5 cm)
Signed
Pennsylvania Academy of the Fine Arts, Philadelphia
(Temple Fund Purchase)

Harrison S. Morris, Director of the Pennsylvania Academy from 1892 to 1905, described Twachtman's paintings as "his fragile dreams in color." This is an apt description of one of Twachtman's most beautiful and more contemplative pictures, *Sailing in the Mist*. Extremely subtle, the subject provides the artist with opportunity for a display of pure painting, a rare manipulation of an overall delicate and balanced relationship of hue against tone.

Yet this beautifully painted canvas is more than that. In his treatment of a single figure sailing a solitary boat amid what appears to be limitless space, with a horizon shrouded in mist, Twachtman has imbued the picture with a dreamlike quality. Laden with ambiguity, it speaks to the unknown, and perhaps the unrealized. "In my mind," he once wrote, "I have finer pictures than ever before. Ten thousand pictures come and go every day. . . ." And in this rendition of a single figure, or a single object, within a seemingly endless space, in his evocation of the solitary—of loneliness even—Twachtman has captured what European critics have often described as the essence of much of American painting.

Twachtman understood abstraction, the nature of things, but he was misunderstood by the public of his day. His tendency toward simplification and subtlety of thought and execution was overlooked or not accepted by a public that did not find enough force or drama in his work. By most of its viewers, *Sailing in the Mist* would have been considered a sketch or, as has been said of his work, too "delicate and dainty . . . too personal."

Twachtman exhibited regularly in the annual exhibitions of the Pennsylvania Academy and won a gold medal for a painting similar to *Hemlock Pool (Autumn)* (Plate 10), much to the chagrin of the local press; but his work did not sell. "Do you know," he wrote to Harrison Morris in 1901, "that I have exhibited eighty-five pictures this year and have not sold one?" And to bear out this disappointment, the Pennsylvania Academy did not purchase *Sailing in the Mist* until 1906, four years after the artist's death.

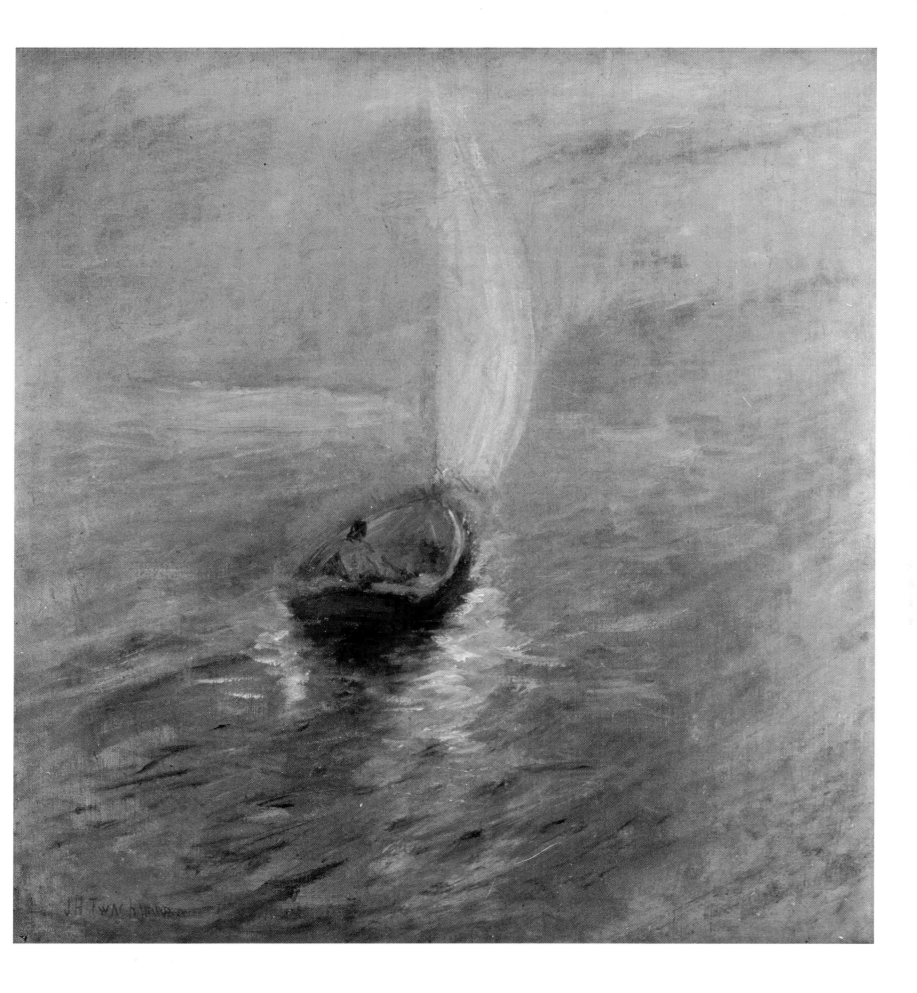

Plate 19
SEA SCENE, 1893
Oil on canvas
28″ × 34″ (71.1 cm × 86.4 cm)
Delaware Art Museum, Wilmington, Delaware

Also called *Marine* or *Seascape*, this painting represents an unusual subject for Twachtman. He was a man apparently not given to extremes, at least not in his work. When he painted his landscapes recording the changes in seasons, it was the regular quiet change that he depicted. He seemed to avoid the drama of the natural scene, the swift or abrupt shifts in wind or weather. He did not paint nocturnal views, and even tired of too much bright sunlight. "There has been so much sunshine for months," he once wrote to Weir, "that a grey day is a fine and rare thing."

Rare also, then, is the violence of the sea depicted here. Executed in purples, blues, and greens, the picture is quite beautiful; he has caught the delicate grayish spray of the waves as well as their underlying force as they pound the coastline and batter the jagged rocks in the foreground.

Knowing Twachtman's philosophical bent, it is tempting to read meaning into *Sea Scene* and relate it to the public's rejection of his work—a symbol of his anger and bitterness. (". . . and the American public will turn you down for second- and third-rate French painters.") However, the implicit violence of the subject (a subject handled with more immediacy and power by Winslow Homer at about the same period) is tempered somewhat by Twachtman's detachment and constraint, by the subdued palette of his modified Impressionism and by an awareness of the deliberate eye at work.

Nevertheless, it remains an infrequent departure into the realm of nature's violence and, for Twachtman, an uncommon look at a disturbing aspect of nature's moods.

Plate 20
NIAGARA FALLS, c. 1894
Oil on canvas
30" × 25⅛" (76.2 cm × 63.8 cm)
Signed
National Collection of Fine Arts,
Smithsonian Institution, Washington, D.C.
(Gift of John Gellatly)

About 1894 Twachtman received a commission from Charles Carey of Buffalo, New York, to paint a series of pictures of Niagara Falls. The results were disastrous. Twachtman's Niagara Falls and Yellowstone Park series, represented by this example and the one following, are an indication of what happens to an artist when he attempts a subject for which he has neither an affinity nor sympathy. Although this is one of the best in the Niagara series, that is not saying much.

As a painter of the quiet and more intimate aspects of nature, Twachtman could not handle the sheer size and power of the Falls, nor could he convey the sense of scale necessary to make the image convincing. In fact, in this picture (as in Plate 21 also), there is no scale whatever. While the arrangement and placement of forms shows his instinct for abstraction, their representation is almost too literal. The brushwork is strained, and the color forced—and uncomfortably sweet.

Plate 21
THE RAPIDS, YELLOWSTONE, c. 1895
Oil on canvas
30″ × 30⅛″ (76.2 cm × 76.5 cm)
Bears Twachtman Estate sale stamp
Worcester Art Museum, Worcester, Massachusetts

Twachtman fared slightly better with his series of Yellowstone Park, commissioned about 1895 by Major W. A. Wadsworth, also of Buffalo. In this series he was better able to indulge his feeling for abstraction, particularly in the paintings of the "Emerald Pool." The falls and rapids in that area were to present him with much the same problem as Niagara.

The Rapids, Yellowstone is a more successful painting than *Niagara Falls,* but it is still uneven and suffers from lack of scale. The treatment of the rapids is reminiscent of the surf in *Sea Scene,* even to the placement of the jagged rocks in the foreground. The latter work, however, is more finely tuned and orchestrated, more unified, than *The Rapids, Yellowstone.* It was more familiar, the sea—as familiar to him as was every inch of his farm, which was to provide him endless subject matter and inspiration, enabling him to create his own special world.

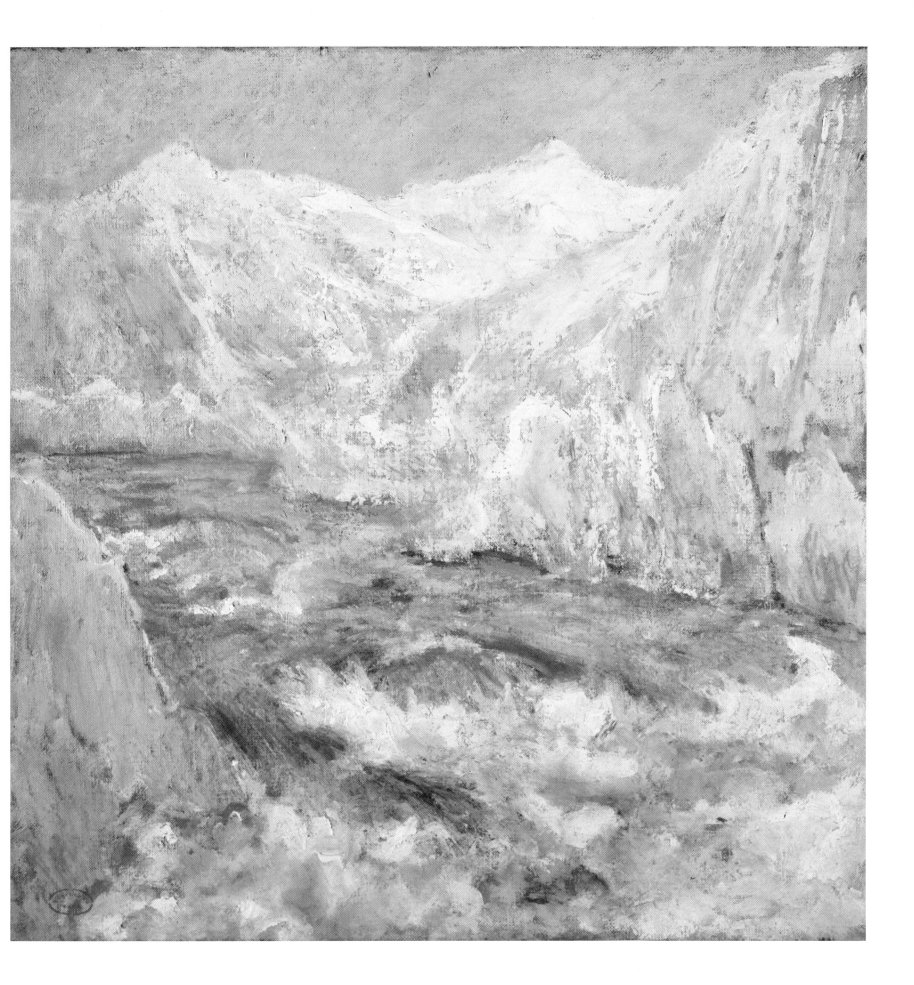

Plate 22
SUMMER, c. 1890–1900

Oil on canvas
30″ × 53″ (76.2 cm × 134.6 cm)
Signed
The Phillips Collection, Washington, D.C.

John Twachtman was the kind of painter whose conceptual process, and the painting method accompanying it, took him from the specific to the general. Whether he painted a bunch of wildflowers, a small pond, or his house, he infused his subject with his own conception, his own point of view, and raised it to another level of reality. And in accomplishing this, he was convincing. Whereas the Niagara and Yellowstone series were neither specific nor general enough, in *Summer* he fully realizes a true sense of light, air, and space; his touch is sure and quick. The house is one with the landscape; all the elements are subtly fused yet hold their own in the picture with an unerring placement, a sure sense of scale, and an equal mastery of color and tone.

Depicted here are the farmhouse and a partial view of the land Twachtman owned on Round Hill Road, about two miles outside Greenwich, Connecticut. He had purchased the property in 1889 with the proceeds from paint-ing the cyclorama in Chicago and from the sale of work exhibited at the Fifth Avenue Art Galleries earlier that year. On the seventeen-acre farm was a small cascade called Horseneck Falls, which fed a stream called Horseneck Brook, which in turn flowed into a little pond known as the "hemlock pool." All three subjects were used by him again and again, painted from many vantage points, at different times of the day, and in different seasons.

His teaching duties at the Art Students League (starting in 1889), and later at Cooper Union, allowed him time to improve his property and explore its possibilities with an eye to indulging his penchant for painting the familiar and the intimate. Like Monet's little estate in Giverny, Twachtman's farm was to be an almost inexhaustible source for his paintings. Like Monet, also, Twachtman took a circumscribed, specific location and made of it an entire universe.

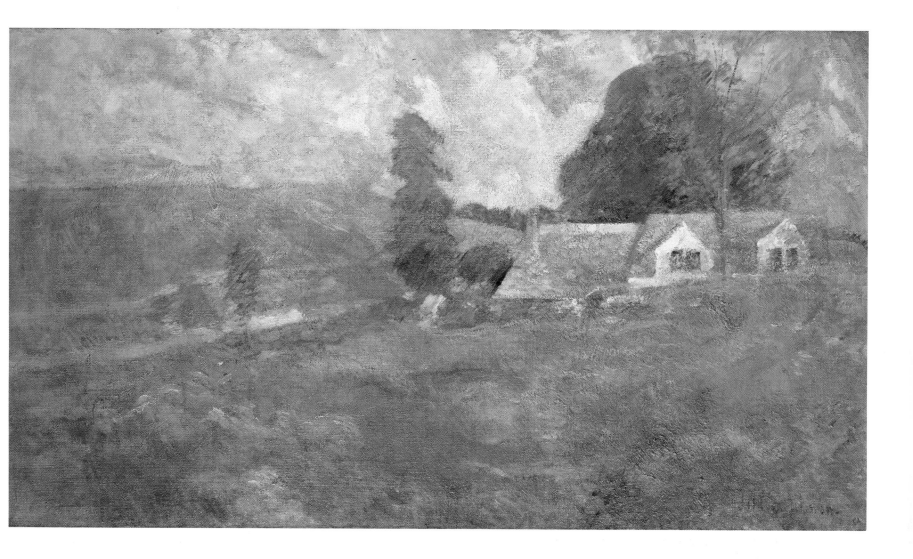

Plate 23
THE WATERFALL, c. 1890–1900
Oil on canvas
30″ × 30¼″ (76.2 cm × 76.8 cm)
Signed
Worcester Art Museum, Worcester, Massachusetts

The artist's son, J. Alden Twachtman, remembers exploring the farm and its acreage with his father just before he bought it. With growing excitement the elder Twachtman surveyed the rolling landscape, the little brook, the small pond, and upon seeing Horseneck Falls, exclaimed with delight, "This is it!"

Both abstract and descriptive in treatment, *The Waterfall* is nonetheless convincing. The cascade painted here is in actuality very small. The square canvas is broken up into a series of flat patterns, yet the tactile reality of the object is all there. There is no doubt about the truthfulness of feeling, or the artist's sympathy with his subject. The vigor with which this picture is executed indicates perhaps that it was painted closer to 1900 than 1890.

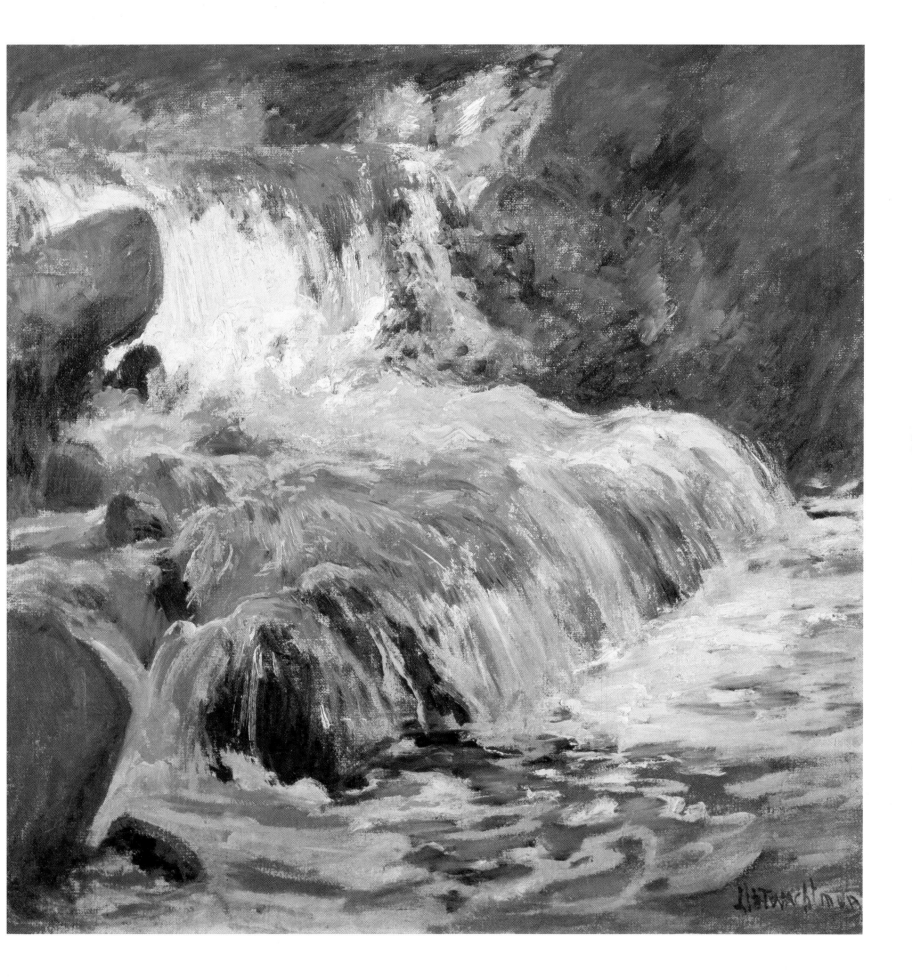

Plate 24
SNOWBOUND, c. 1895
Oil on canvas
25¼″ × 30⅛″ (64.1 cm × 76.5 cm)
Signed and dated "1884" [questionable]
The Art Institute of Chicago, Chicago, Illinois
(Friends of American Art Collection)

Also called *Icebound* (see Hale, no. 320), this painting is dated "1884" at the lower right; that date, however, is a curious mistake. The subject is the hemlock pool on Twachtman's farm, which he would not have painted before buying his property in 1889. On the basis of subject and style, then, a date of about 1895 would be much more likely.

It is the onset of winter once again, and layers of snow have crystallized and hardened into abstract shapes. Although heavy, it is an early snowfall shown here, for not all the leaves have fallen from the trees and the remaining ones are tinged with the orange hue of autumn. The red-orange, orange, and brown tones so exquisitely arranged form a sequence of distinctive accents played against a neutral, softly modulated background ranging from white and gray to a dark (by comparison) blue-gray. It is at once a carefully observed, descriptive picture and a quite abstract composition, particularly in its handling of shapes and of close tonal relationships among the subdued grays and whites in the middle distance and background.

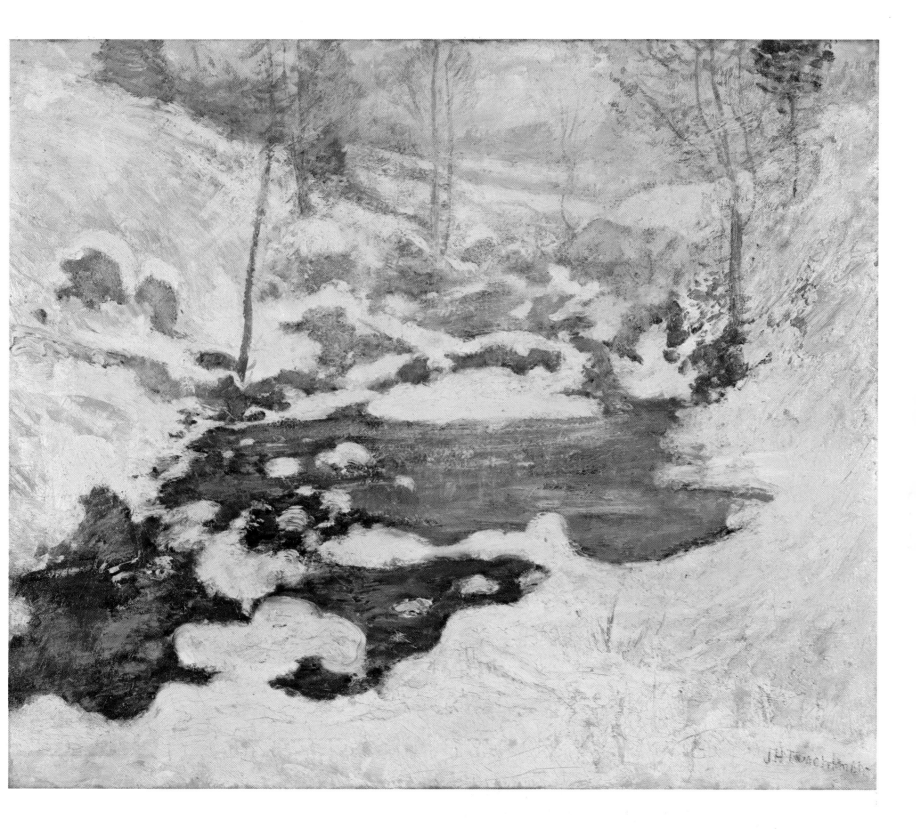

Plate 25
HEMLOCK POOL, c. 1890–1900
Oil on canvas
30″ × 25″ (76.2 cm × 63.5 cm)
Signed
Addison Gallery of American Art, Phillips Academy,
Andover, Massachusetts

The shapes of *Hemlock Pool* emerge as the snow recedes with the coming of warmer weather. The same scene as *Snowbound* (Plate 24) is here given a differing aspect and a different feeling by the vertical emphasis, the openness, and the depth of its point of view.

Professor Hale dates this painting about 1900 (Hale, no. 255a), and it was dated 1902 for the Cincinnati Art Museum's retrospective (Cincinnati catalogue, 1966, no. 71), but it is not certain that it was painted as late as 1900. It would, perhaps, depend upon when Twachtman began his White Bridge series, as he seems to have built a little bridge across the pool sometime after the mid-1890s (see Plates 27, 29).

John Gallatly, one of the great collectors of the period, bought this work in 1902, the year of the artist's death. Of more interest perhaps is the fact that it was exhibited in New York at the International Exhibition of Modern Art—the famous Armory Show of 1913.

Although the picture is strong, it is also low-key; its subtle relationships and quiet brown tonalities were out-shouted by the noisy color and violent abstractions of the European modernists in that legendary exhibition. When the furor over Marcel Duchamp's *Nude Descending a Staircase* had died down, a little of American art died with it. In the ensuing scramble to come to terms with the new modernism, the pursuit of a quiet observation of fact within the framework of an idealistic, contemplative, and romantic vision of nature as represented by a painting such as *Hemlock Pool* was lost.

Toward the end of the century Twachtman's own work underwent a perceptible change and became more vigorous and bold, foreshadowing an Expressionist rather than an Impressionist approach.

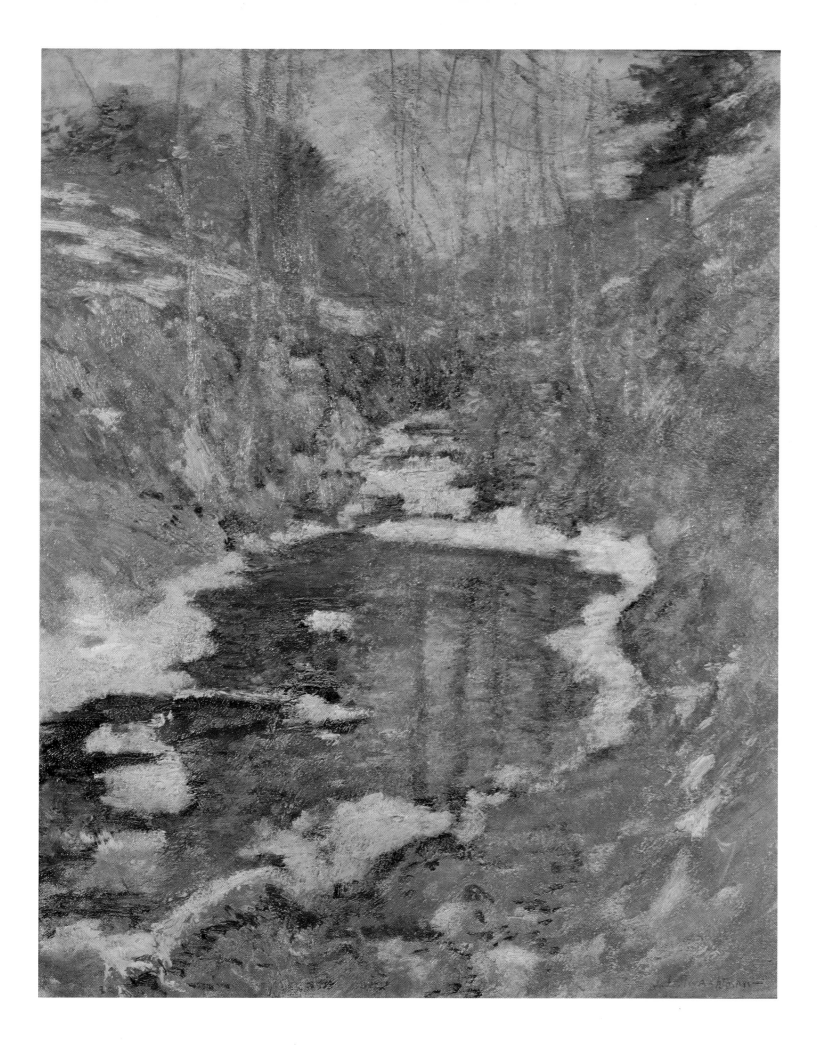

Plate 26
A SUMMER DAY, c. 1900
Oil on canvas
25" × 30⅛" (63.5 cm × 76.5 cm)
Signed
The Indianapolis Museum of Art, Indianapolis, Indiana
(John Herron Fund)

Twachtman was a landscape painter from the start, and the little figural painting he did was not very successful. There was always a certain detachment in his work, a certain distance. Usually the figures, portraits of his family for the most part, were too obviously mere elements in a composition; but when the figures became an essential and integral part of that aesthetic scheme and his structure, as in *Sailing in the Mist* (Plate 18) and *A Summer Day*, the results were quite different and much more satisfactory.

In *A Summer Day* the figure of the child in the rowboat is very definitely a major element in the picture, conceptually and structurally; in fact, it is the underlying concept. The idea is simple enough and borders on sentimentality and cliché. It is saved, however, by the artist's conscious distance from it, the detachment and austerity of his approach. The simplicity of the idea is expressed in complex brushwork forming an interlocking pattern of color and tone. The curve of the boulder is echoed in the curves of the child's back and the stern of the boat, both partially illuminated by sunlight and darkened by shadow.

The child's figure gives a sense of scale to the work and heightens the size of the boulder, making it appear larger than it really is. The rock itself sits on the edge of the hemlock pool, as seen in the lower left of *Winter Harmony, End of Winter,* and *Misty May Morn* (Plates 11, 13, 14), but the intense focus Twachtman provides here gives the impression that the little hemlock pool is an immense lake, again indicating his talent for taking a modest corner of the real world and giving it added dimension.

Professor Hale assigns a date of about 1900 to this canvas, (Hale, no. 6086), and it does seem to show a stronger, more contrasted and vigorous approach that Twachtman began to employ around this time.

72

Plate 27
THE WHITE BRIDGE, after c. 1895
Oil on canvas
30¼" × 30¼" (76.8 cm × 76.8 cm)
Signed
The Minneapolis Institute of Arts, Minneapolis, Minnesota
(Gift of the Martin B. Koon Memorial Collection)

Like Monet at Giverny, Twachtman continually worked on and improved his property, thus creating more elements for use in his painting. Possibly after the mid-1890s, he built a small footbridge toward the head of the hemlock pool. If the artist's vantage point is rendered correctly (the boulder at the pool edge that he painted many times appears at left), then some of his pictures might need a revision in date. The bridge is not in evidence in *Misty May Morn* (Plate 14), dated 1899, or in *Snowbound* (Plate 24), probably painted in 1895. Professor Hale dates this picture circa 1893–1898 (Hale, no. 89), but it is probably safe to assume it was done after 1895.

The subject is approached here with a combination of diffidence and daring. The viewpoint is frontal, and the picture space is shallow. The bridge is partially obscured by the tree in the foreground, yet its stark whiteness holds its own both in space and on the surface of the canvas. This is a composition of changing surface shapes and linear patterns of light and dark, quite different from the Rochester version (Plate 29), which has the benchmarks of Twachtman's change in style around 1900.

74

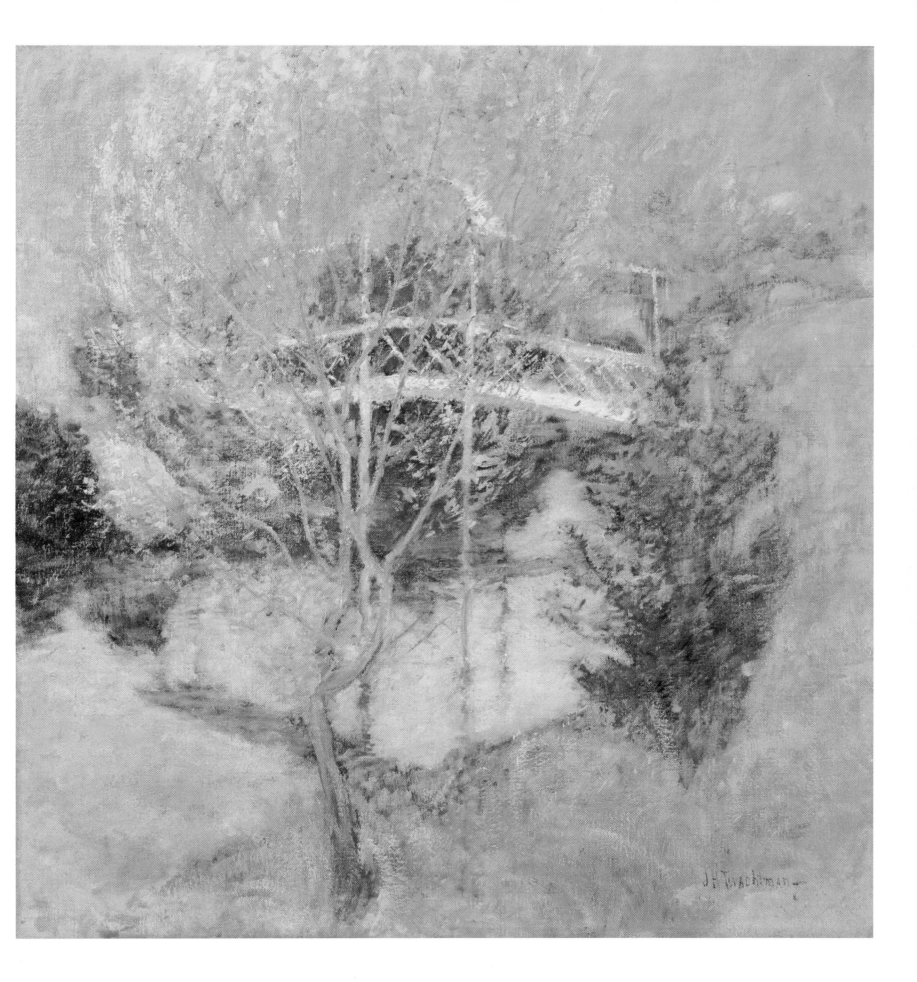

Plate 28
FROM THE UPPER TERRACE, c. 1890–1900
Oil on canvas
25" × 30" (63.5 cm × 76.2 cm)
Signed
The Art Institute of Chicago, Chicago, Illinois
(Friends of American Art Gift)

This painting of Twachtman's farm as seen from an elevated viewpoint shows his major concern for the visual aspects of design and color. In fact, the abstract structure, the strong linearity, and the thrust and counterthrust of diagonals almost overpower the natural subject itself. The dull, dry, physical surface of the canvas is characteristic of his work at this time, and the matte surface is perhaps in reaction to the smooth finishes of an earlier period, in part probably as a result of his work in pastel. Nonetheless, the pictorial structure of *From the Upper Terrace* appears more frankly exposed than usual, and its design is similar to and seems to forecast the strong diagonals of *Harbor View Hotel,* the last picture Twachtman painted.

Plate 29
THE WHITE BRIDGE, c. 1900
Oil on canvas
30" × 25 " (76.2 cm × 63.5 cm)
Signed
Memorial Art Gallery of the University of Rochester,
Rochester, New York (Gift of Mrs. James Sibley Watson)

There is nothing diffident about this version of *The White Bridge*. Painted in a more direct, open manner than the Minneapolis version, it recalls once more Twachtman's propensity for tackling the same subject again and again. In this painting of the little bridge he makes more use of deep space, and his technical approach reflects a change to bolder brushwork and more pronounced contrast of light and dark, similar to his handling in *A Summer Day* (Plate 26).

Most of his subjects are drawn from the country landscape on his farm, subjects with which he was "in accord." As Weir said, "He was in accord with nature, winter or summer, and a day with him in the country was always a delight." Nevertheless, his discernible change in style about this time seems to have been a result of working intensely in Gloucester, Massachusetts, where he and his friends painted in the summers of 1900 to 1902.

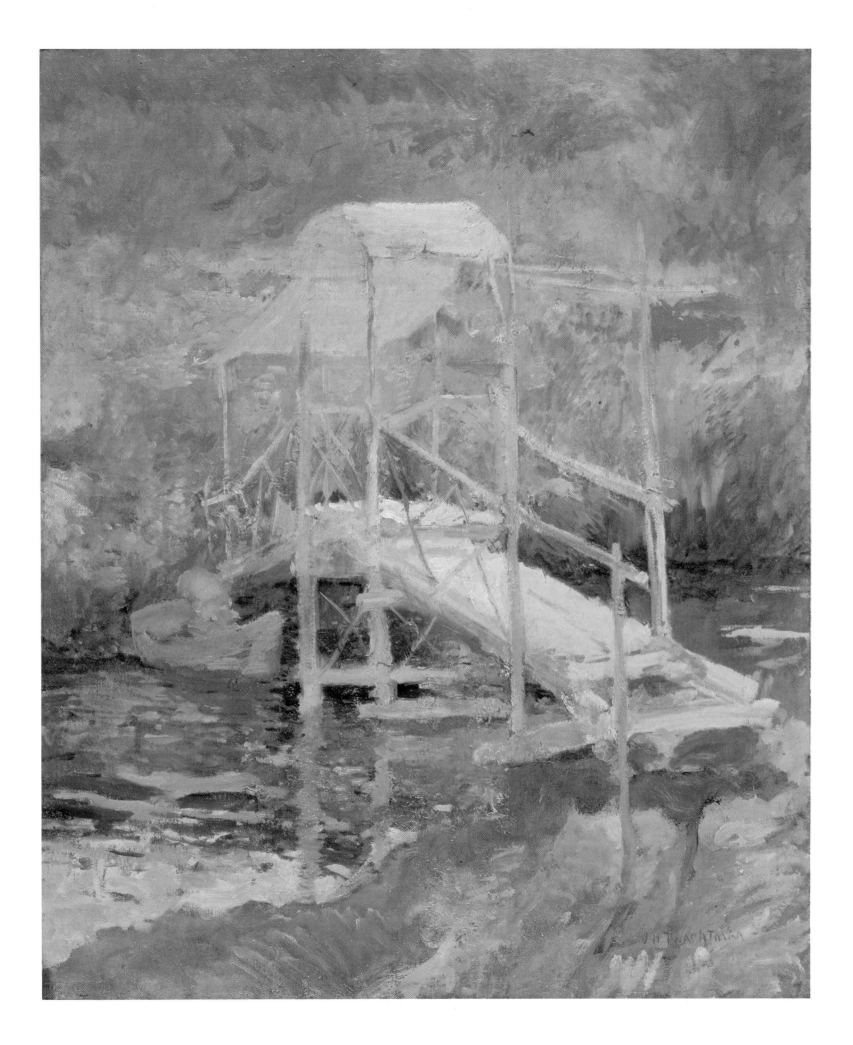

Plate 30
FISHING BOATS AT GLOUCESTER, 1901
Oil on canvas
25⅛" × 30¼" (63.8 cm × 76.8 cm)
Signed
National Collection of Fine Arts,
Smithsonian Institution, Washington, D.C.
(Gift of William T. Evans)

In the summers from about 1900 to 1902, Twachtman and his colleagues painted in the fishing town of Gloucester, Massachusetts. They congregated at the Harbor View Hotel (Plate 32) in East Gloucester, which became a haven for artists. Gloucester itself had been associated with American art for many years, ever since the mid-nineteenth century, when Fitz Hugh Lane lived there (his studio is still preserved).

It is in his Gloucester pictures that Twachtman's change in style becomes noticeable. This shift was not radical or sudden, to be sure, but was evident enough to be commented on by the critics. A reviewer in the *New York Daily Tribune* of April 2, 1902, talked of "a clarifying process" his work had undergone and the fact that his hand had "become firmer."

"Looking on the decks of vessels. Grey and white," he wrote on the back of a thumbnail sketch of *Fishing Boats at Gloucester*, one of the paintings typical of his work in this period. In addition to the gray and white and his usual palette of rose madder, ultramarine blue, and cadmium yellows, he introduced black, a color he had eschewed up to this time. Like the Rochester version of *The White Bridge* (Plate 29), *Fishing Boats* is based on a structural framework using strong diagonals to indicate depth. This spatial suggestion is reinforced by his directional brushwork, implying the movement of the boats and underlining the busy pattern of masts and variously shaped houses along the docks. The picture feels as if it were painted in a single sitting, a technique he learned in Munich and from Frank Duveneck. Indeed, in many of these late paintings, it looks as if Twachtman had reverted to an earlier manner, which he improved, updated, and reintroduced in the work of the last few years of his life.

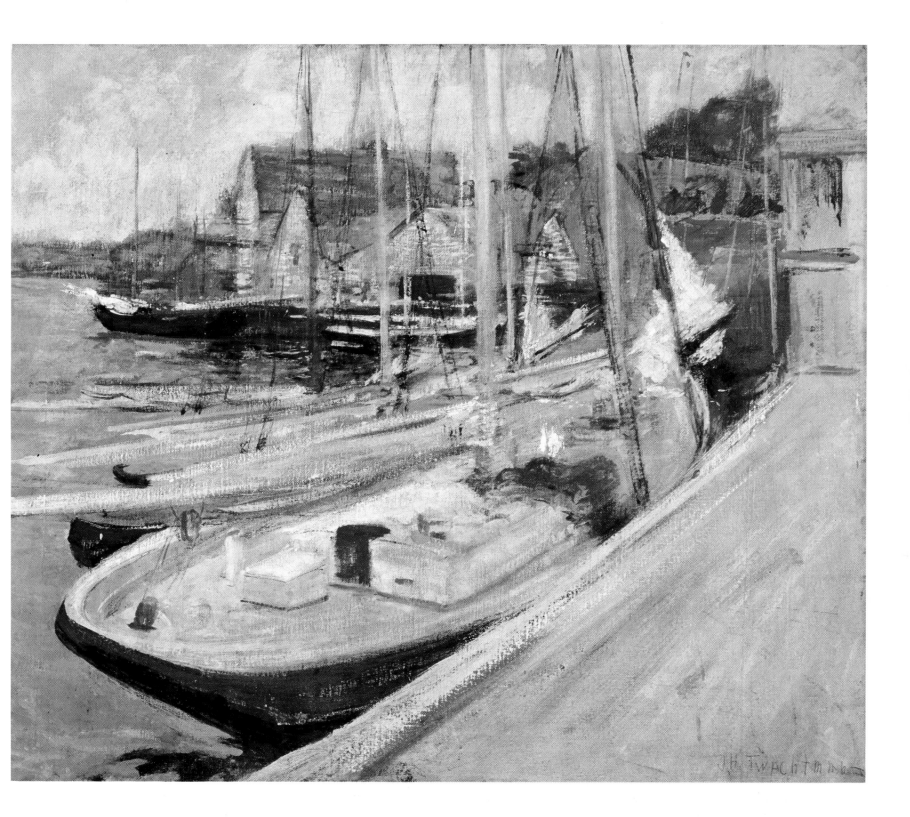

Plate 31
ABOARD A STEAMER, c. 1900–1902
Oil on panel
14½" × 9½" (36.8 cm × 24.1 cm)
The Kennedy Galleries, Inc., New York

The small size and immediacy of *Aboard a Steamer* indicates that it was probably painted *alla prima*, "all at once." The handling is sure and direct, and the prominent use of black not only gives some indication of its dating but also adds to the impression of a powerful abstract picture, despite its small size.

This is an unusual subject for Twachtman. His philosophical and contemplative response to landscape generally precluded industrial subjects; yet the bold abstract shapes and strong color, the almost "hard-edge" (for him) approach, of this painting do indicate a decided and positive reaction to such subject matter. It is a rugged and beautiful little picture, executed with an almost Expressionist vigor—a direction in which he seemed to be moving when it was cut short by his untimely death in 1902. "His art," as the *New York Daily Tribune* said, "has increased in personal force."

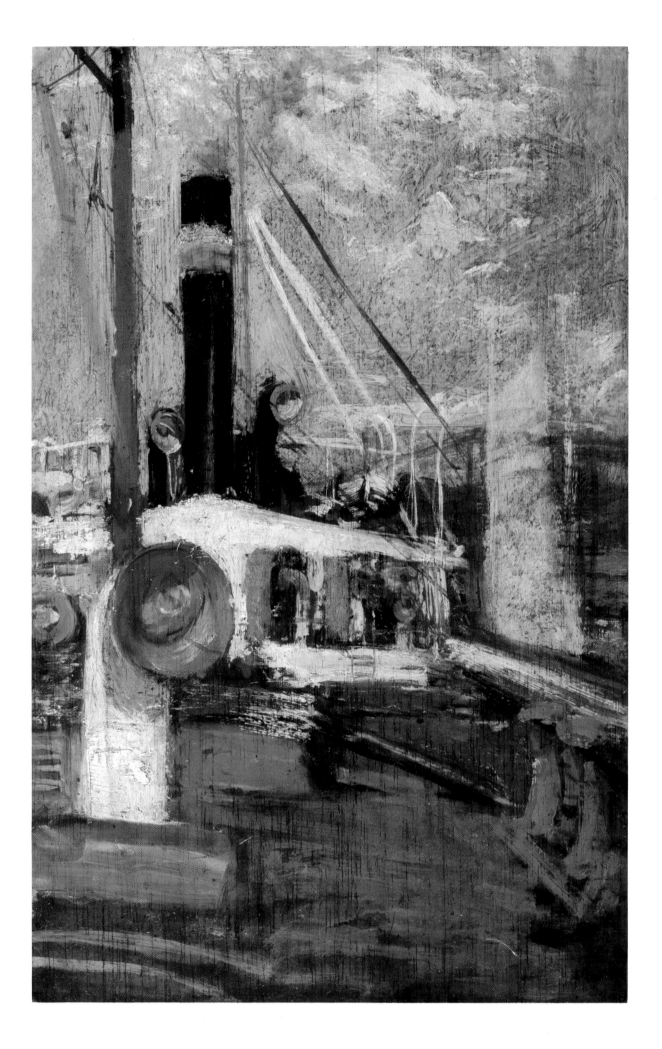

Plate 32
HARBOR VIEW HOTEL, summer 1902
Oil on canvas
30" × 30" (76.2 cm × 76.2 cm)
Nelson Gallery—Atkins Museum,
Kansas City, Missouri (Nelson Fund)

According to the artist's son, Colonel J. Alden Twacht-man, this unfinished view of the hotel in East Gloucester where the artist stayed was the last canvas Twachtman painted.

Reminiscent of *From the Upper Terrace* (Plate 28), *Harbor View Hotel* adopts the prominent diagonals the artist began using to construct his compositions at this time. Since the picture is unfinished, it also provides some indication of Twachtman's working method. Basic to his painting, even before he started, was a long and deep familiarity with his subjects. At Gloucester, the painter Abraham Walkowitz used to see Twachtman studying the countryside, learning "to know every spot, even their moods," so that when he put brush to canvas he had "lived through it before he began." As evidenced in *Harbor View Hotel*, his basic idea was expressed, and often realized, in his initial "blocking in" of colors and shapes, accomplished with the first few strokes of his brush.

Harbor View Hotel is technically unfinished, yet the concept is fully realized. The idea was taking shape in his mind before it began to form on the canvas. ("Ten thou-sand pictures come and go every day. . . . ") The quality of his pictorial structure—the underpinning, so to speak—is very much in evidence here. This is what Childe Hassam was referring to when he wrote an appre-ciation of Twachtman's work in 1903: "The great beauty of design which is conspicuous in Twachtman's paintings is what impressed me always; and it is apparent to all who see . . . that his works were . . . strong, and at the same time delicate even to evasiveness."

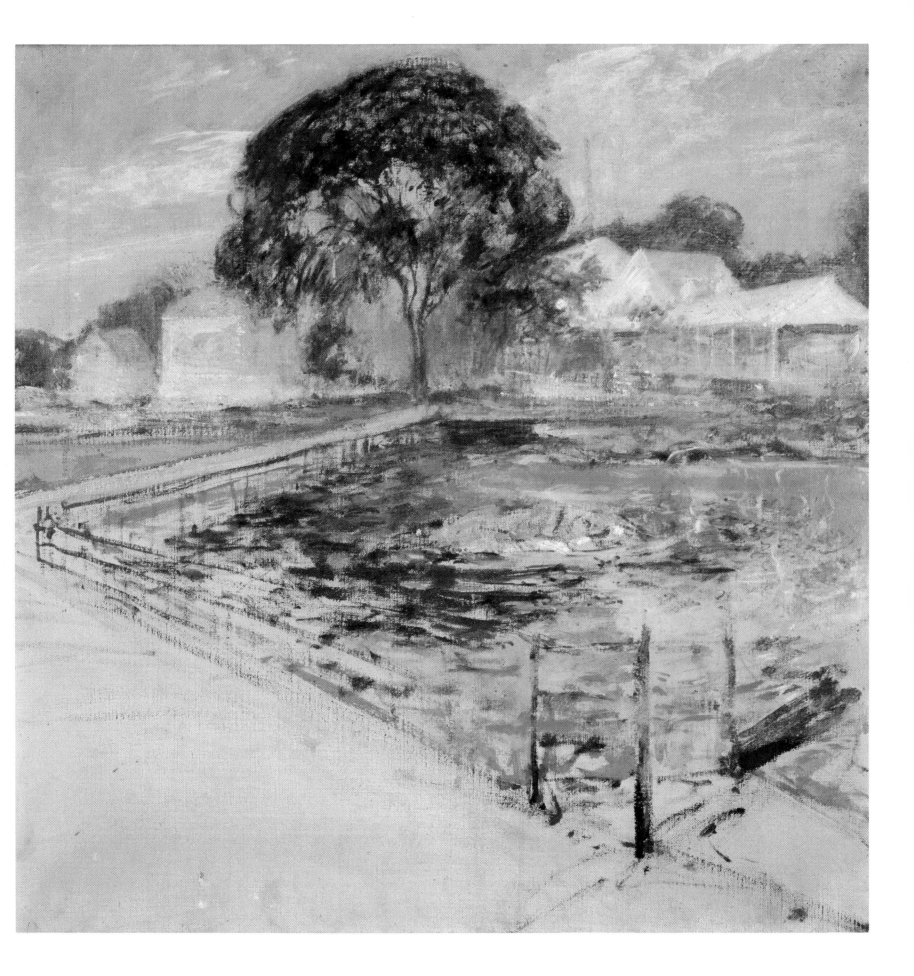

Bibliography

Note: Biographies of John Twachtman are few, and because much of the material about him was written in the context of his position as an American Impressionist, I have included some of the important sources on that subject here.

TWACHTMAN

Books. The standard monographs on Twachtman are: R. J. Wickenden, *The Art and Etching of John Henry Twachtman*, New York: Frederick Keppel & Co., 1921; Eliot Clark, *John H. Twachtman*, New York: Frederick Fairchild Sherman, 1924; Allen Tucker, *John H. Twachtman*, New York: The Whitney Museum of American Art, 1931. (Both Clark and Tucker were former students of Twachtman.) The most thorough and exhaustive study on the artist is found in Professor John Douglas Hale's admirable unpublished Ph.D. dissertation, *The Life and Creative Development of John H. Twachtman*, 2 vols., Columbus: Ohio State University, 1957 (published on demand by University Microfilms International, Ann Arbor, Mich., and London, England).

Magazine Articles. Thomas Dewing, Childe Hassam, Robert Reid, Edward Simmons, and J. Alden Weir, "John H. Twachtman: An Estimation," *North American Review*, 176, no. 1, April 1903, pp. 555—557; Duncan Phillips, "Twachtman—An Appreciation," *International Studio*, 66, February 1919, pp. cv—cvi; Carolyn C. Mase, "John H. Twachtman," *International Studio*, 72, no. 286, January 1921, pp. lxxi—lxxv (Mase was an important early biographer who knew the family well; Professor Hale refers to her unpublished notes for the above article); Richard J. Boyle, "John H. Twachtman: An Appreciation," *American Art and Antiques*, 1, no. 3, November-December 1978, pp. 71—77.

Exhibition Catalogs. *Presenting the Work of John H. Twachtman: American Painter*, Munson-Williams-Proctor Institute, Utica, N.Y., November 5—28, 1939; *A Retrospective Exhibition: John Henry Twachtman*, The Cincinnati Art Museum, Cincinnati, October 7—November 20, 1966 (essay on Twachtman's painting by Richard Boyle; on his prints, by Mary Welsh Baskett); *John Henry Twachtman: An Exhibition of Paintings and Pastels*, Ira Spanierman Gallery, New York, February 3—24, 1968 (Introduction by Richard Boyle; Foreword by Dr. J. Douglas Hale).

AMERICAN IMPRESSIONISM

Books. Donelson F. Hoopes, *The American Impressionists*, New York: Watson-Guptill Publications, 1972; Richard J. Boyle, *American Impressionism*, Boston—New York: New York Graphic Society, Ltd., 1974.

Exhibition Catalogs. John I. H. Baur, *Leaders of American Impressionism*, New York: The Brooklyn Museum, 1937; F. Van Deren Coke, *Impressionism in America*, Albuquerque: University of New Mexico, 1965; Moussa M. Domit, *American Impressionist Painting*, Washington, D.C.: 1973.

Note: Because Jules Bastien-Lepage was an influence on American painters (in the 1880s J. Alden Weir was an ardent admirer, and Alexander Harrison, Robert W. Vonnoh, and Ridgeway Knight, among others, studied with him) and because I believe his work bears a closer look (along with that of the Americans mentioned above), I include the following bibliographical material: C. H. Stranahan, *A History of French Painting*, New York: Scribners, 1888, pp. 466—471; W. E. Henley, *A Century of Artists*, Glasgow—New York: 1889, pp. 3—5; Richard Muther, *The History of Modern Painting*, vol. 3, London: J. M. Dent & Co., and New York: E. P. Dutton & Co., 1907; *The Past Rediscovered: French Painting 1800—1900* (exhibition catalog), The Minneapolis Institute of Arts, Minneapolis, July 3—September 7, 1969 (introductory essay by Robert Rosenblum; unpaged).

Index